Design by Thinking

Editor Ken Cato
Design Cato Partners
Colour separations by
Sang Choy, Singapore
Printed by
Tien Wah Press, Singapore

Design by Thinking

First published in 2000
by Craftsman House for
HBI, an imprint of
HarperCollins Publishers
10 East 53rd Street
New York, NY 10022-5299
United States of America

Distributed to the trade
and art markets in the U.S.
by North Light Books,
an imprint of
F&W Publications, Inc.
1507 Dana Avenue
Cincinnati, OH 45207
(800) 289-0963

Distributed in Australia
and New Zealand by
Craftsman House
42 Chandos Street
St Leonards
Sydney NSW 2065

Distributed throughout
the rest of the world by
HarperCollins International
10 East 53rd Street
New York, NY 10022-5299
Fax: 212 207-7654
ISBN: 0-06-019843-5

Special thanks to Chris Budgeon
for his photograph on page 61
and to Jeff Moorfoot for his
photograph on page 74

Design by Thinking | Ken Cato

Amongst corporations, institutions, government bodies, businesses and their products, the search for a powerful identity has become one of the single most important factors in achieving a strong marketplace presence and financial success. World markets are cluttered with organisations, products, entertainment and electronic services providing all sorts of information that, via visual means, demands our attention. Our tolerance for pursuing anything that is not considered vitally important is almost non-existent. We are able to simultaneously absorb many visual messages, so we are no longer content to read through sales catalogues or press advertisements until we reach the last page or the bottom of the ad to discover who is trying to talk to us. Our leisure time is just as valuable. We surf the television channels or the Internet and move on quickly if the programme or website is not sufficiently interesting ■ Not surprisingly, most of the messages we receive and retain are visual. It's also visual communication that allows us to cross international language barriers, giving us access to the global marketplace. Beyond traditional media, international corporations have numerous visual components that reflect the attitudes and personalities of the company and its products. Stationery, corporate literature, annual reports, product design, packaging, merchandising, advertising, transportation, corporate headquarters, manufacturing plants, retail outlets, corporate wardrobe, uniforms and websites all have a role to play. Many of these are never regarded as communication tools, yet millions of dollars are invested in them every year ■ Still, most traditional identity programmes that designers have developed for organisations in the past only satisfy a small part of the equation. While the

trademark has been the cornerstone of these systems, it has historically only reinforced the most well-recognised reason for its own existence, acting as a thumb print or instant identifier for the corporation, organisation or product. The trademark has never provided a system that enables recognition prior to or beyond the well-worn 'sign-off'. This is no longer enough. What we at Cato Partners call a 'Broader Visual Language' must be established for each organisation or brand, if it is to fully harness its visual resources. Broader Visual Language is a graphics system that allows a corporation, business, brand or organisation to communicate successfully at all times and therefore gain maximum marketplace presence. The most obvious and appropriate consultant to help achieve the optimum result is the designer. In many quarters, designers have been seen generally as part-time communicators, full-time organisers of information, and often as visual decorators. In the future, it's only those designers whose work is driven by ideas, the need to truly communicate with understanding, and a vision for Broader Visual Language that will survive the business arena. And it will be only those who practise

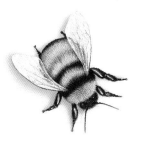

design by thinking

A sincere thank you.
There are so many people
to be acknowledged and
thanked. Although my name
is on the door, it is those
who have worked with me
throughout the years who
deserve much of the credit
for the company's success.
So much of it has come
from working with people
who share common goals:
the pursuit of excellence,
the love of design, and the
profound realisation that
good design improves
the quality of our lives.
Their talent, energy and
dedication are the vital
ingredients in both the
growth of the company
and the continuing search
for higher standards.
The work contained in
this book is not the work
of one person: it is the
accumulated achievement
of the people known as
Cato Partners. And it
is them I thank from the
bottom of my heart for
their talent and support
in making the company
what it is today

Ken Cato

How to own a blank sheet of paper

While developing the original visual identity components for Cato Partners, we realised that the company had many needs. One of these needs was how to identify an A4 sheet of letterhead that would also be used as follow-on sheets and report pages. Combined with the same need across a number of local and international offices, this meant that we potentially had numerous simple stationery items that required stock control, and which incurred substantial costs as soon as we applied the individual company name and location. By simply establishing a distinct cutting form, and die-cutting different quality and types of blank paper, we were able to distribute the correct paper in appropriate quantities. Single production runs are also advantageous as they allow each of our offices to get what they need at an affordable rate. At the time we had not considered that this would become the cornerstone of our identity: not a logotype or a symbol, but the complete form of the item itself. This simple but highly effective graphic device has provided continuity in the development of our most recent corporate identity programme ■ The cover, endpapers and introductory graphics for this book come from the new identity for Cato Partners. The die-cut pages you would immediately recognise, but the graphic images, which are only new to the company, are totally different from the simple typographic layouts that portrayed our identity in a time when design was perceived as mere decoration. At Cato Partners, we have always believed in putting forward a serious business identity for our company in order that our thinking and skills be taken seriously in a professional context.

The form-cut concept was extended to business cards with individual details simply changed on the back of each card. Whilst these details were printed in a single colour, the main identity was reproduced in full colour with an embossed bee

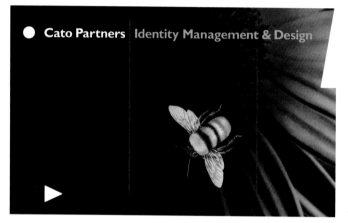

Our chosen typography and colour has always been restrained, dignified and has consciously never been too trendy or over-designed. So, while retaining the basic premise that has brought so much success for our business and those of our clients, we have literally gone out to practise what we preach: the development of a Broader Visual Language ■ The words 'Identity Management & Design', which we use to position our business, are difficult and abstract things to build a visual language around. But 'Partners' has provided us with a theme that is absolutely relevant to the way we work internally; the way we endeavour to work with our clients; and the way we work with our fellow consultants. The language we sought had to be broad, flexible and appropriate to who we were and who we had been. Above all, it had to be unique and highly memorable.

It also had to be interesting and have the ability to expand and be developed as the company evolved. As a starting point, we endeavoured to identify relationships and partnerships in the natural world that existed on the basis of co-dependence ■ Internally, we encouraged all members of our design teams, management teams and support staff to contribute their thoughts. We telephoned zoos, aquariums and museums until we finally arrived at a list of symbiotic relationships we considered to be the most potent, and graphically the most easily translated. Some were instantly better understood by a majority, some more interesting visually and others more intriguing by virtue of the relationship. Our list of favourites included: the bee and the flower; the rhinoceros and the tick bird; and coral and the clown fish. There were also more inanimate relationships, such as the nut and bolt (a true analogy for our financial and procedural documents) and a needle and thread. We explored numerous ways of expressing these relationships before finally settling on a number of basic graphic elements that would form the basis of the system. Working with the foundation visual components of typography, our corporate colours and the die-cut form, we introduced another component, uneven brackets, as a way of defining the desired relationship and containing groups of information. Through a contrast of scale and various illustration techniques, we set out to use this Broader Visual Language to actively demonstrate the partnerships we have, and to provide a solid structure for those of the future

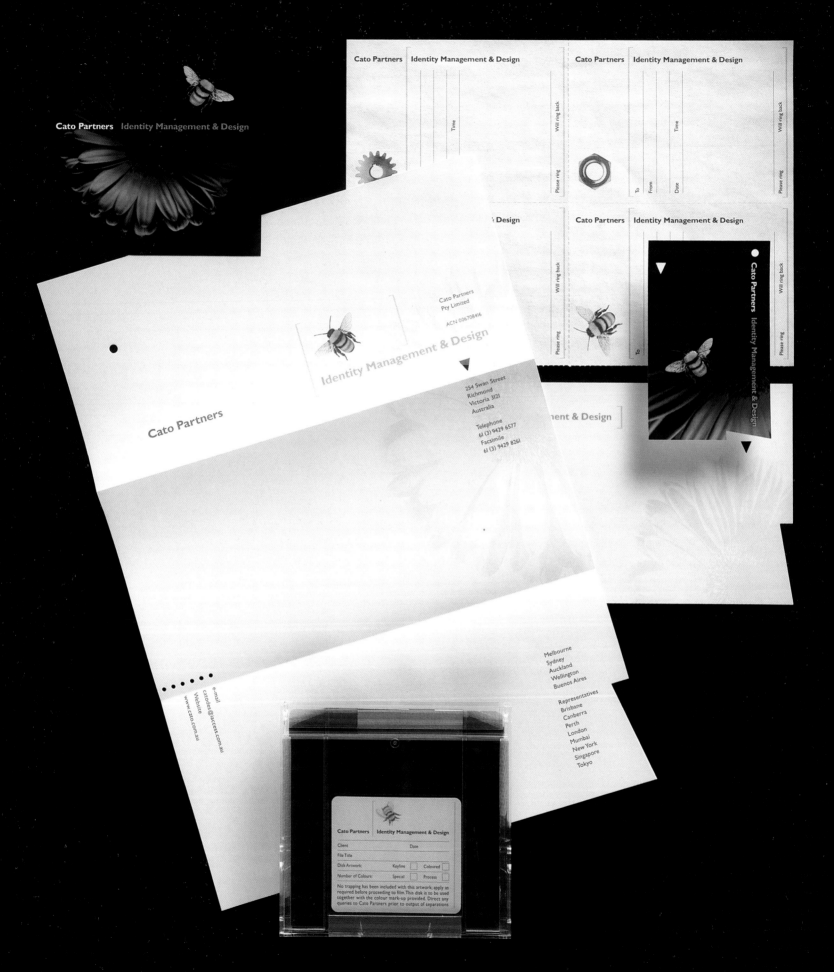

Understanding the words as well as the pictures

In an effort to make this book easier to understand, I felt it important to clarify some terminology. In numerous business and design conversations, I have heard the very casual use of a number of words critical to the communication process. It seems that no matter how inaccurately these terms are applied, or despite the fact that each person uses them to represent something different, all those involved in such a conversation seem to nod in agreement. I'm not sure what this really indicates, but I think it is important to ensure that these terms, at least in this book, are consistent and do only refer to one thing ■ I often hear the word 'image' used by client and designer when they really mean 'identity'. Some companies even claim that they can control a corporation's image. The reality is that the only thing that can be influenced by the designer is the identity. This can be managed predominantly through those tangible visual components that represent the organisation. 'Image' is another matter. Designers have absolutely no control here. It is totally in the eye of the beholder. The image of anything is influenced by numerous factors: the point of viewing, the visual appearance and familiarity, as well as the previous experiences or relationships with the subject, object or identity ■ While its physical state remains unaltered, the actual form of an object can be and is often perceived differently. Therefore, when I refer to a corporate or brand identity, I am only referring to those visual components that can be influenced by the designer. Often I hear people refer to a 'logo'. This is not necessarily the trademark. The word does not refer to a symbol; it is an abbreviation of the word 'logotype' which, in the context of this book, purely refers to the way in which the corporation, organisation or brand writes its name. It is quite simply another way of saying 'wordmark'. Normally the logotype would contain some distinct character, alteration or addition to the way in which the letters are written or combined, or it would distinguish the overall appearance of the word. Of course, this could also be referred to as a 'trademark'. A trademark can also be an abstract or realistic symbol, pictogram or illustration that is used to represent a corporation, organisation or brand. All the trademarks in this book have relevance to the corporation, organisation or product. Each of them has an idea at the heart of its evolution, and all of them were created through 'design by thinking' ■ A term that appears throughout this book is 'Broader Visual Language'. This is a term that Cato Partners uses to describe the visual characteristics and structure of the graphic elements that comprise the communication language for an organisation or brand. This is not a common term within the profession, and there are other words and phrases that address some or all of the related issues. In the next section I'll explain the structure and theory of Broader Visual Language using, as a specific example, the project that gave birth to the definition and philosophy that drives most of the work done at Cato Partners

In search of a Broader Visual Language and effective communication

In 1989 I was fortunately introduced to a highly intelligent and aware president of a Japanese development and construction corporation. Tsukita San guided C'est La Vie at a time when there was a great deal of activity in the property development market in Japan. I thought the name was odd. A Japanese company with a French name was unusual, and so was the way in which the President interpreted it. To Tsukita San, C'est La Vie meant 'doing it my way'. The project started much as any other. We knew we had to create a new identity for a company that had at its core, classical architectural excellence. But in the briefing stage we understood the need to acknowledge the relationship between the architecture and the people who inhabited or related to it. The cold clean architectural structures seemed at odds with the warm and humanistic qualities that were needed to complete the equation. At the same time there was an awareness within C'est La Vie that environmental issues were also something they wished to address. Of course there were the usual physical and cost constraints that call for common sense as well as creativity. We knew at worst we had to create a solution that would allow the new identity to be applied initially

Allowance was made in creating the main symbol for its form to alter according to the characteristics of major architectural projects undertaken by the company

to building site hoardings, utilising simple interpretive skills and without costly implementation ■ The central idea did not appear instantly, nor was it ever totally apparent in the initial stages of development. Under normal circumstances, no design would begin without the design team fully agreeing on a clear idea that has potential to be extensively developed. Instead we began by creating a classic typographic statement for the words 'C'est La Vie' which was then placed centrally in the simplest of architectural forms – a black square. To our minds, this shape was representative of a building or closed environment. We believed that the square gave us the base symbol which we planned to graphically sculpt or adjust according to the architectural style or characteristics of the buildings under construction. It also provided us with a method of keeping the identity fresh and recognisable, while making provision for future expressions of the company's architectural projects. Whilst this was a good start, it did not

The ancient Chinese Tangram provided the relationship of the building's form, and the parts were rearranged to convey different expressions of the people who inhabited the structures

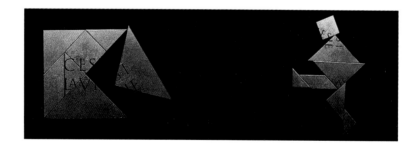 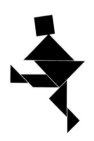

address the issue of human interaction. We needed another idea or an extension to our initial concept ■ During the course of working on projects in Asia, I had come across the ancient Chinese puzzle known as the Tangram. While not new, it was square and geometrically divided; the Tangram would allow us to reassemble the elements of the square (our original architectural structure) using the variously shaped pieces to create numerous interpretations of human forms. The Tangram was the key to visually creating a direct relationship between the building and the people who interacted with it. Better still, it gave us the opportunity to have these figures express different emotions or messages about the company or the building under construction. Inquisitive, joyful or just simply there, the figures graphically communicated C'est La Vie's presence, and they were instantly identifiable from a distance. The different figures were easily applied, becoming a real vehicle for conveying far stronger and more complex messages than any single symbol or trademark ■ These figures were the beginnings of a language that allowed the company to speak in its own voice, in a language that would translate across all constructional, print and electronic communications

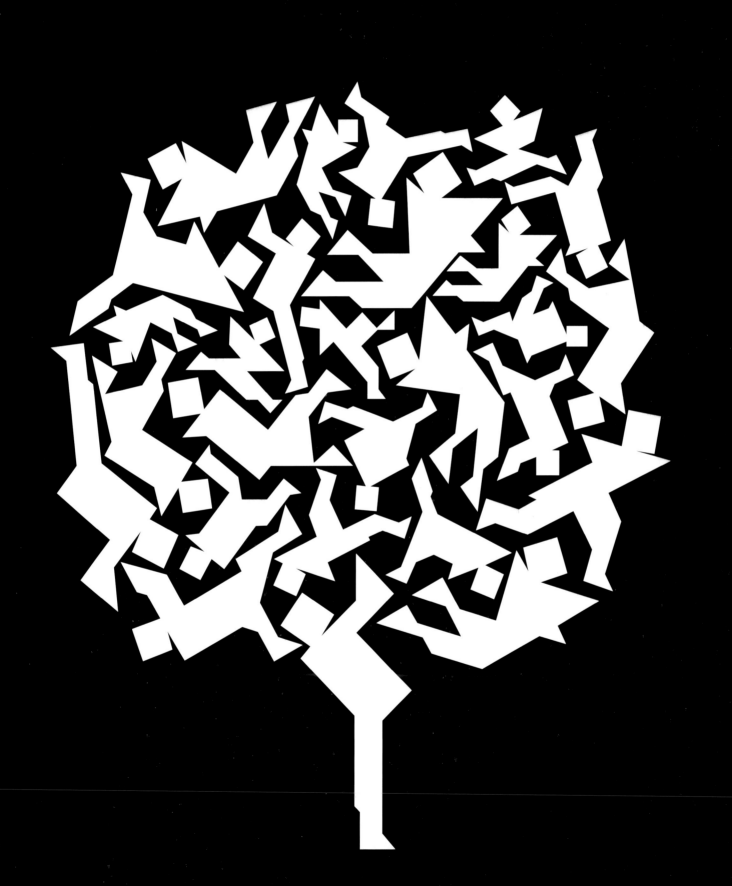

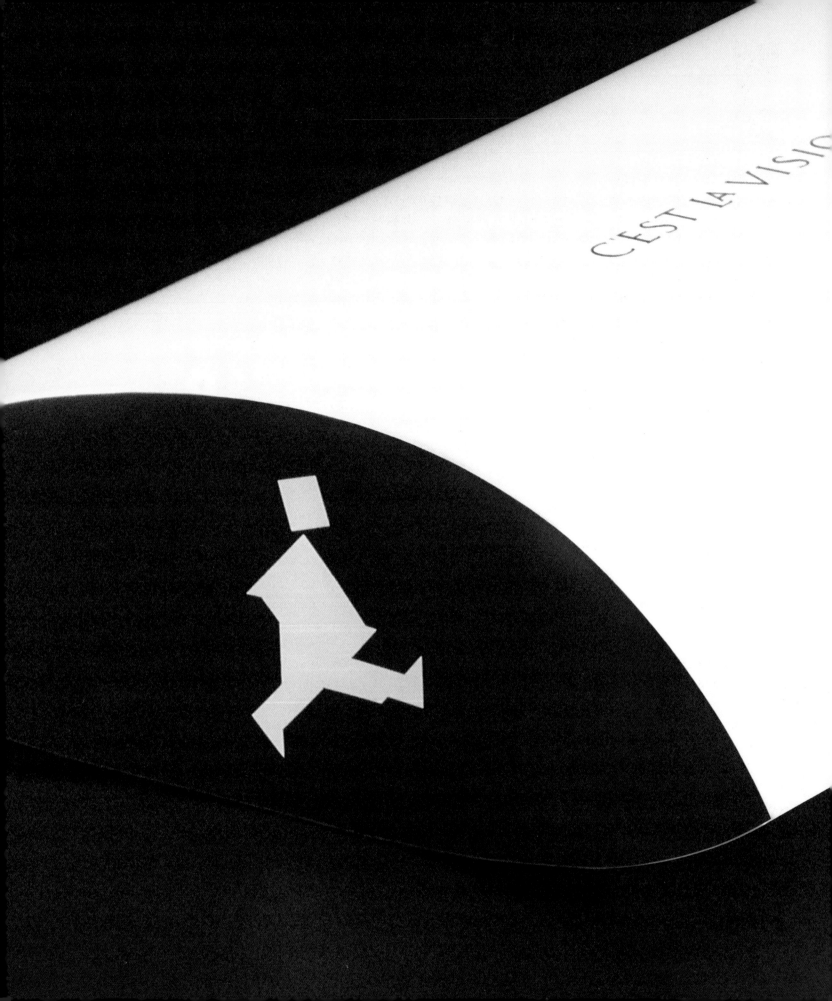

C'EST LA VISIO

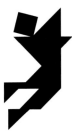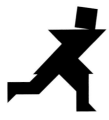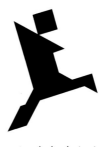

The Broader Visual Language created for C'est La Vie allowed us to speak about the environment simply by bringing the figurative graphics together to form trees. Later, the environmental statements were to become far more developed and expansive ■ During the development of this project, we had added a new dimension to the corporate identity programmes that we had traditionally developed. Some twelve months later we were to make more discoveries, when C'est La Vie decided to diversify and develop a business which would source or manufacture items that related to a 'way of living'; often the products would be planned for use in the interiors of buildings that C'est La Vie had designed and constructed. The President's vision for the company was discussed in great detail. The constant use of the word 'vision' pre-empted a slip of the tongue and the birth of the new company's name: 'C'est La Vision'. As we had already created a broad-based visual language for the parent company, the new

When reorganised, the geometric pieces form many expressions of the human personality, from inquiry to celebration

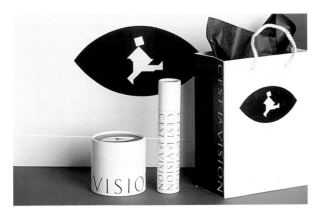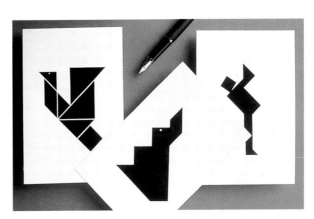

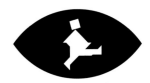

trademark and expression of C'est La Vision came almost automatically. While it was distinct, it was also obviously part of the C'est La Vie family. The extensions of the company into other areas was so instant and clear that the whole focus of the communication could be directed towards the essence of the message, confident that C'est La Vie's presence was ensured because of the identifiable nature of the language itself ■ To our minds this concept of corporate identification was so logical, powerful and flexible, that we knew it was no longer enough just to expect the passive trademark to clearly communicate the presence, essence and message of a company. While we are still strong advocates for a powerful symbol and a well-structured identity programme, we believe that unless it incorporates a strong Broader Visual Language the opportunity to compete in a crowded, impatient marketplace is truly limited. The following pages demonstrate practical applications of this philosophy

The C'est La Vision trademark was a natural extension of the main company identity that still expressed the sentiment of the C'est La Vision name

There were many opportunities to design new products. Rather than design new shapes for card holders, variation was created in the disposable component of the product

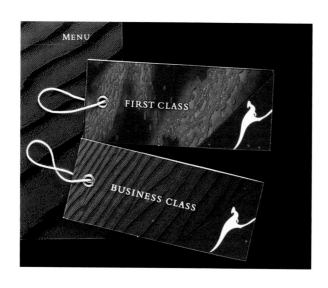

Baggage tags, ticket wallets and menus utilise the landscape as a colour-coding device while providing another view of the Australian landscape. The language of the landscape visually integrates all corporate material, from aircraft interiors to pages on the website

The fourteen First Class passengers receive an individual menu at meal time. Different photographs of the Australian landscape provide a contrasting overview of the Australian terrain

Australia's international airline, Qantas, has a symbol that's well-recognised the world over; so well known that often there is no need to use it with the company name. While it does an outstanding job of identifying Qantas, it has its limitations in being able to integrate all the visual aspects of the organisation

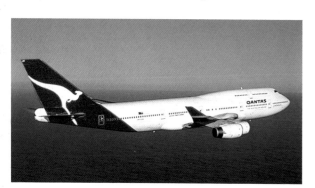

An aircraft cabin branded with red triangles and white kangaroos seemed inappropriate, as did an airport lounge covered in symbols. Instead we decided to use the theme 'The Best of Australia' as the glue to hold everything together. Understanding and defining what the 'best' really meant was far more difficult to pin down until the Australian landscape itself became the theme. Of course, any Australian company could 'own' this theme, but there are very few companies for which the view of Australia from 35,000 feet would be appropriate. We discovered an Australian landscape rich in colour, texture and pattern that in its diversity provided continuity as well as a neverending source of inspiration. Aerial photographs of the rivers inspired the fabric design for the First Class cabin and a series of glass screens used in the Chairman's Lounge

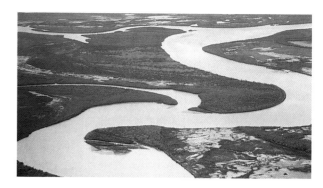

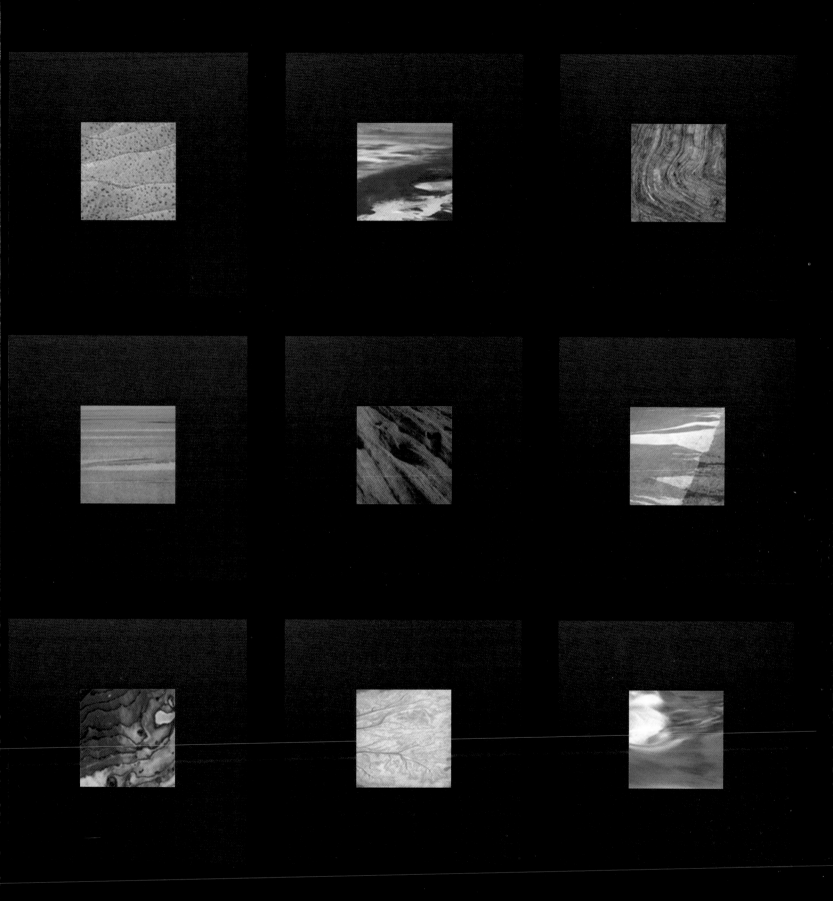

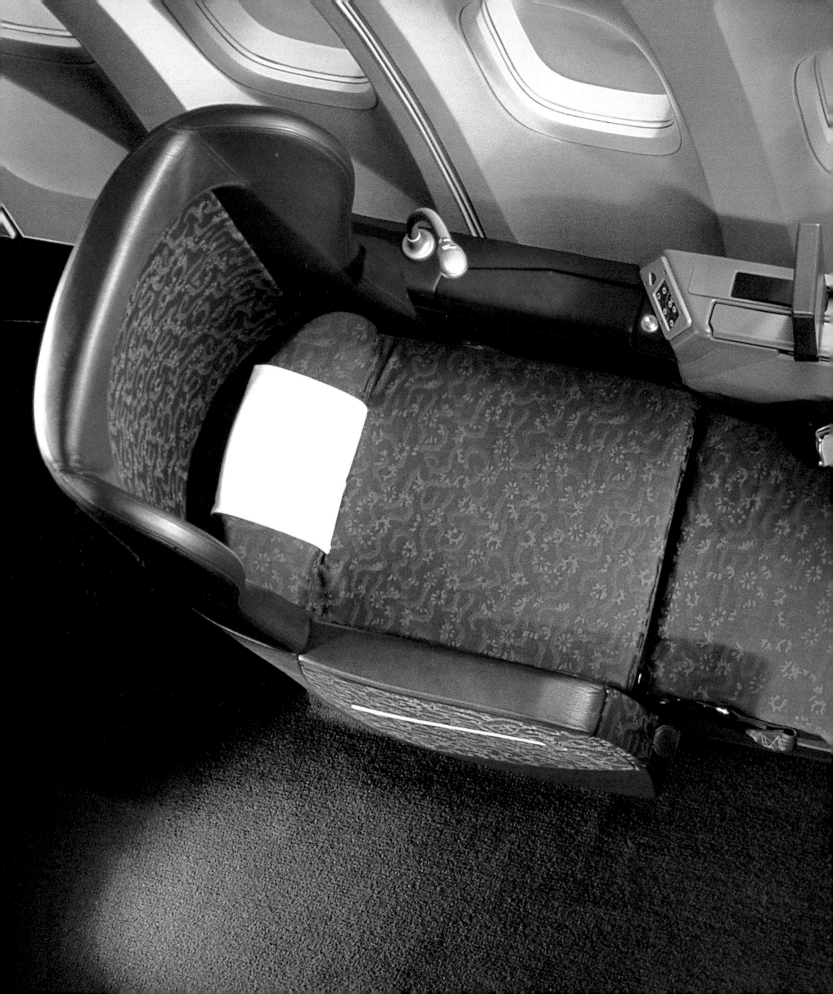

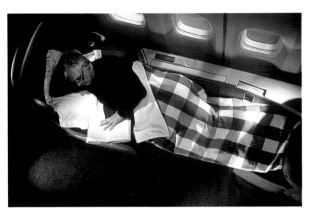

This generation of the First Class seat fabric was inspired by the unique forms of Australian coral reefs, and it provided a rich colour palette of opulent deep blues. The new Economy Class fabric was based on the sea anemone, also found in the reefs of Australia

The second generation of cabin interiors continued the established theme but allowed total integration during the transition from the first generation to the recent upgrades of the aircraft. The first Qantas website incorporated photographs of the landscape with iconic visuals to give graphic interest to the onscreen information

The landscape viewing position was reversed, casting a shadow that emphasises Qantas' concern for issues related to the environment

QANTAS for a sustainable future

BankWest

When R&I Bank changed its name to BankWest, it adopted a symbol that draws on the security and calligraphic marks found in banknotes and security documents. This concept formed the basis of a Broader Visual Language that allowed the organisation to coordinate everything from printed material and manufactured signs to the corporate wardrobe. In launching the new identity, an animated videotape reconstructed the symbol taking a journey through the intricate structuring of Australian banknotes. The system successfully enabled the total integration of over 2000 items used in the Bank's everyday activities

NK OF · WESTERN AUSTRALI

BankWest

With our impatience and propensity for changing television channels, creating an identity for Arc Music TV provided a significant challenge: how to own the television screen so that the channel was instantly identifiable to viewers switching channels no matter what was on

The name provided the answer. The concept of using the arc as a device to intrude on the screen provided a simple broad-based visual language. Whether the screen was cut completely in half or the arc was used as a small corner cut, the programme recognition was immediate

Working with production house Revolver, the idea was extended through story boards to make the concept come alive on screen

ARC

Chiquititas has been Argentina's leading children's television programme for over four years. In redesigning the brand identity to align the programme more closely with the target audience, a complete alphabet of characters was developed to create more interesting looking words and sentences. Random combinations of letters can also convey individual stories and relationships, and many Argentine children now use the new alphabet to write their own names on schoolbooks

The individual letters have also become performing characters in a stage show developed from the television programme. The opening credits incorporate animated versions of the alphabet in combination with a live action performance. The continuity and evolution of the logotype has provided a highly flexible and harmonious visual landscape that has led to innumerable franchising opportunities. Such is the success of the programme that separate casts provide the same material to Argentina, Brazil, Uruguay and Mexico

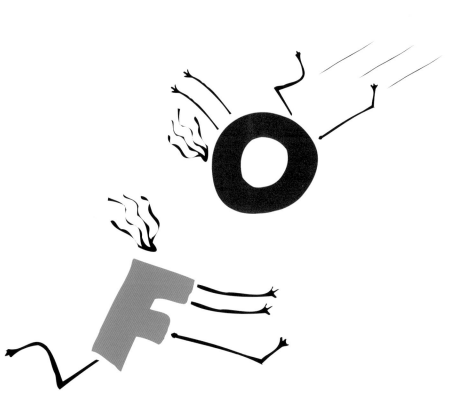

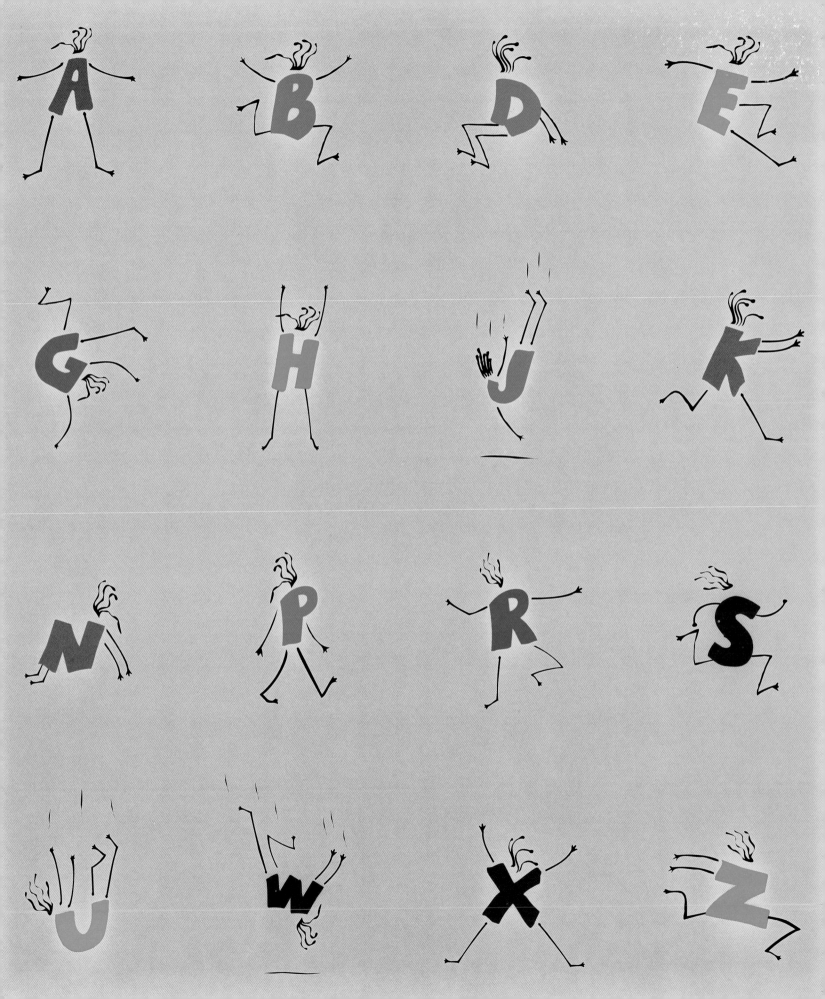

energex

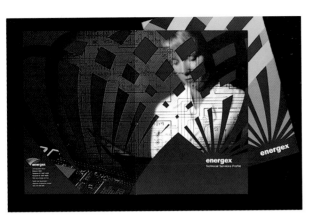

homesuite

earth'schoice

first call

gas

Energex is one of the leading distributors and suppliers of power to the state of Queensland. Using the notion of a power network, the way that the company actually distributes power, the identity is an exciting and dynamic visual representation of the company's day-to-day operations

We extended the corporate identity to the company's brands and business divisions, therefore establishing a Broader Visual Language that is unique to the organisation

Energex wanted to promote energy efficiency, so we adapted the colourful network structure for use on a CD-ROM of software that allowed businesses to calculate their power consumption

Homesuite is a retail division that provides products for the home, so we again translated the identity to an easily identifiable symbol

For Earth's Choice we wanted to represent the company's conscious use of renewable energy resources, and First Call reflects its commitment to customer service. When Energex expanded its business divisions to include a gas company, we used corporate colours to redefine a familiar symbol

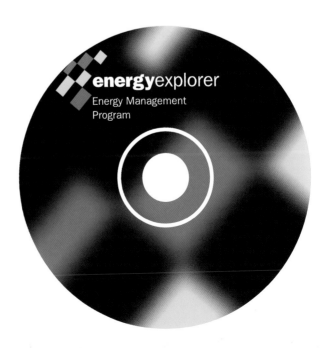

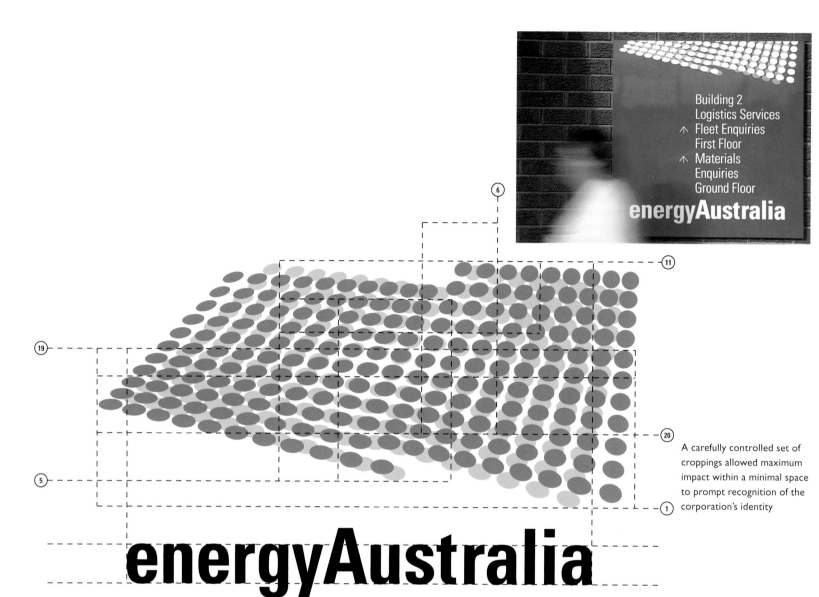

Building 2
Logistics Services
∧ Fleet Enquiries
First Floor
∧ Materials
Enquiries
Ground Floor
energyAustralia

A carefully controlled set of croppings allowed maximum impact within a minimal space to prompt recognition of the corporation's identity

energyAustralia

A change of name and identity was necessary when Sydney Electricity combined with Orion Energy to form energyAustralia, the largest electricity distribution network in Australia. This change was to have been reflected with the introduction of a new symbol; however, the briefing stage of the project indicated that a number of applications required consideration of their extreme proportions. Visibility of the symbol would be limited in the smallest dimensions, whilst there would have been an excess of clear space in the larger dimensions

The idea was based on an illuminated city and a visual demonstration of energy at work. Unusually, this programme was based on a trademark that was deliberately designed to be cut up, and carefully constructed croppings meant that brand presence could be maximised no matter what the proportion or format

Three months prior to the launch, the corporation became a major sponsor of the Sydney City Zoo and, without disclosing the 'new' identity, there was a need to ensure that the 'current' identity and the new identity would be recognisable in both the lead-up to, as well as after, the launch of the new identity. The Broader Visual Language, a graphics system based on the characteristics of the corporate symbol, provided an illustration style that was instantly recognised once the new identity was unveiled

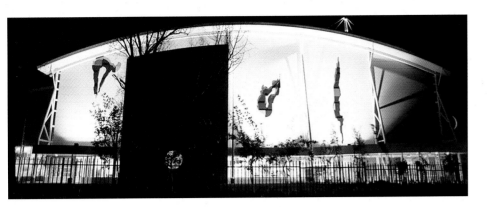

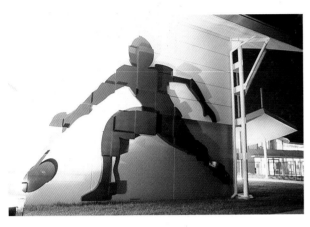

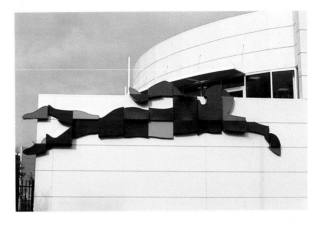

The Melbourne Sports and Aquatic Centre is the largest integrated sports and leisure complex in Australia. The Centre features state-of-the-art facilities that can accommodate community needs, and state, national and international sporting events. Two key factors provided the basis of the identity development leading to a concept of Broader Visual Language

The first factor was the architectural structure of the complex; and the second was the idea of movement seen in the refracted images created by swimmers in and under the water. The left-hand page shows the first visualisation of the pool tiles combined with the sport itself. This illustration became the foundation for the development of numerous sporting images that incorporated movement and the building's architectural characteristics

The symbol for the Centre drew on the characteristics of the Broader Visual Language, with an interpretation of the building's distinct roof structure. Sporting figures became freestanding sculptures, and friezes and painted graphics help to break up the large spaces and flat planes of the building walls

The building signage incorporates sporting sculptures, while the forecourt utilises freestanding sculptures. The metal forms combine with water elements to provide a colourful and dynamic entrance. Simply painted, integrated sporting figures provide identification while adding colour and light to large wall spaces in each area of the complex

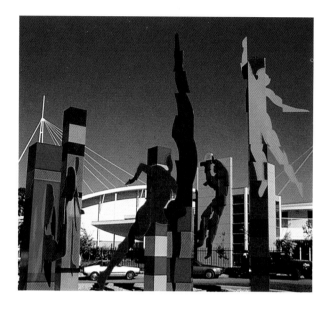

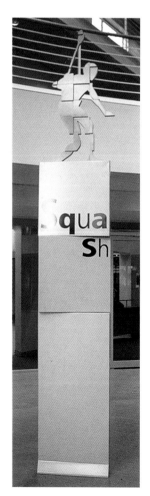

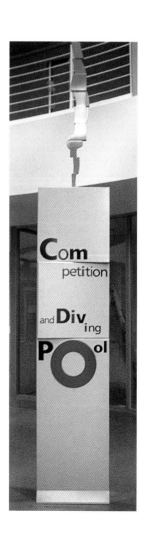

The lane markers for the lap pool provided an opportunity to be different. Rather than a regular broken-line tile pattern, the lanes are defined through the use of different colours and tile patterns, and a system of small to large graphics that helps the swimmer to gauge the distance to the end of the pool

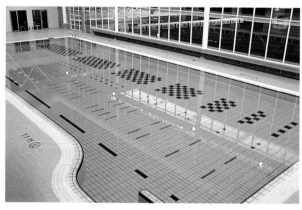

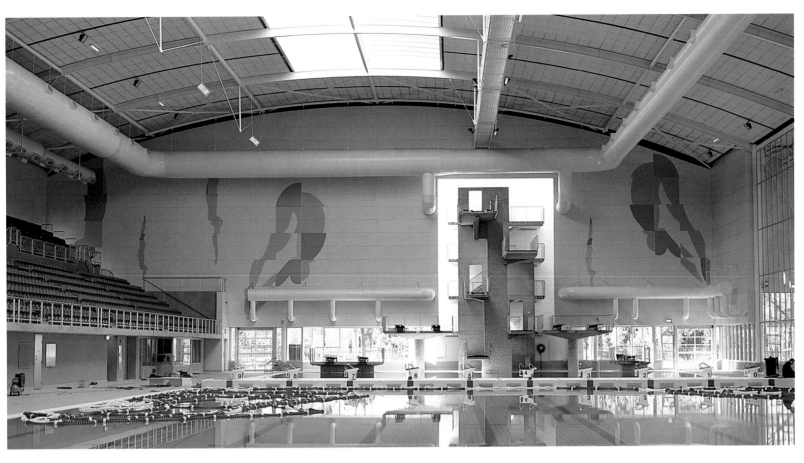

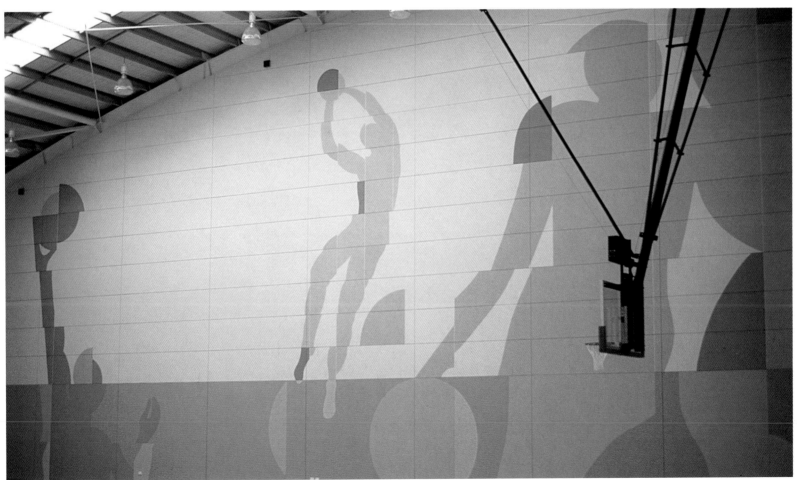

Many corporations go to great lengths to create individual identities that set them apart from competitors, but more often we're seeing organisations collaborate in new business ventures

Occasionally an organisation has a strong need to combine their trademark with the trademark, or trademark characteristics, of another company when forming a joint business venture. When Channel Nine and Microsoft combined to create the ninemsn website, the result was a symbol that combined both identities. Channel Nine's existing nine dots were combined with the arc from the Microsoft identity. To add life to an interactive system of navigation, we developed a spotted dog. The canine character in its various guises now opens the different sections and pages of the website while the presence of the nine-dot trademark is retained

Top, left to right: Community, Classifieds, Magazines; middle, left to right: Health, Lifestyle, Members Only; bottom, left to right: Shopping, Entertainment, TV Shows

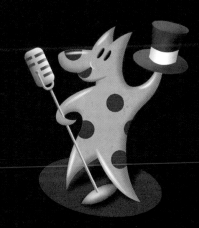
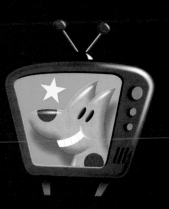

The loneliness of the corporate symbol

Since the dawn of time, symbols have been a meaningful form of communication. Quite often they've allowed us to communicate faster and more effectively, and to break through any language barriers that may have existed. Our world today is full of symbols, sometimes seen on their own and at other times in context with other symbols. And their lifespan depends on their ability to communicate ■ Often the corporate symbol is used as the cornerstone or the only real component of a corporate identity programme. While acknowledging the importance of the trademark as something that establishes presence, it is essential to understand that the most effective symbols are generally simple in structure, have the ability to be used on a very small scale as well as large, will reproduce legibly via electronic communications, reproduce in single or multi colour, and integrate and relate to the other components of an identity system. Most importantly, the symbol must be unique in identifying the business, organisation or product amongst its competitors, and it should convey something about the service, product or business through its appropriate graphic structure. It's not necessary for the symbol to be literal in form or content for it to be successful. However, the more explanation needed for it to be understood, the more money or exposure it will require to gain high recognition ■ Amongst the symbols in this chapter there are a number of examples that state or restate the obvious. More often this higher recognition value makes for a faster means of communication, providing that it's possible to make the obvious the property of the product, service or organisation. In a marketplace which demands that many symbols, logotypes and trademarks are unique, being appropriate and being visible demands a strong idea and design by thinking. Each of the following fulfils these criteria

The symbols shown here and on the next two pages have a common source: all of them were inspired by celestial bodies, planets or the globe. And while these symbols are not new, they are all relevant to the message that needs to be conveyed

SBS is a multicultural television station bringing the world to its viewing audience. Opening up the globe in a literal way provided a distinct trademark that powerfully restates the familiar

Global communication is an obvious statement. These distinct graphics and colour scheme formed the basis of an identity programme for one of Telecom New Zealand's divisions: retail outlets that assist people in business

The development of a poster for the Sydney 2000 Olympic Games saw an Australian icon, the Southern Cross, combine with the Olympic colours and the five Olympic Rings to form a combination of elements that provided a strong statement for an Australian Olympic Games

BankDirect was New Zealand's first 'virtual' bank. Combining technology and the globe was an obvious solution

GAMES OF THE XXVII OLYMPIAD · JEUX DE LA XXVIIe OLYMPIADE

The development of an identity programme for Australia's largest bank demanded the introduction of a more contemporary appearance. The well-established corporate colours of yellow and black were unique in the Australian financial sector, but due to their intensity these colours were often perceived as overpowering. Finding a way to use them with some degree of sophistication became the objective.

The solution came in the form of a symbol based on the Southern Cross constellation

Other configurations within the diamond shape format allowed the Bank to individually identify its divisions. Over 5000 items used to manage the Bank's operations carried the new identity with the highly visible yet restrained use of the traditional colour palette

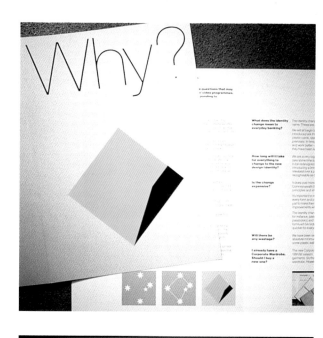

 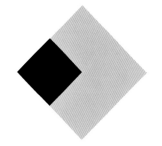

Below: After developing the identities for Infratil in New Zealand and Australia, we also created an identity for Infratil International. The symbol is based on the globe to represent the link between the companies and their extensive operations

Opposite: The identity for Coles Supermarkets evolved when Australia's largest food retailer changed its name from Coles New World. The new global symbol simply replaced the words 'New World' as well as simplifying the identity

JUNO

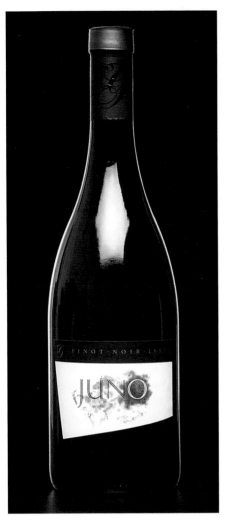

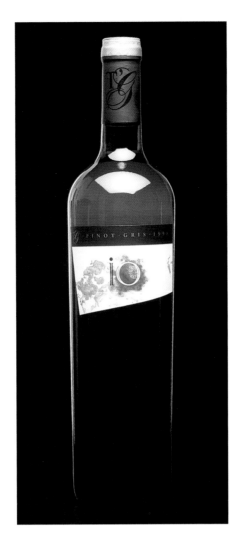

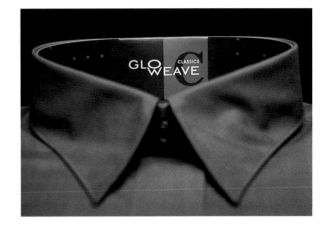

When the T'Gallant winery on the Mornington Peninsula released two new wines, we worked with the winemakers to develop names that reflected the hedonistic experience the wines provided

It seemed that one idea would work for both. Juno and Io are names of celestial bodies. Reflecting this in the logotype became a simple matter of converting the 'O' to represent the moon or a planet

Often, within words, individual letters suggest the final result. In this case the letter 'O' combined with the letter 'W' provided us with a graphic of a shirt collar for Gloweave, one of the country's leading shirt manufacturers

There was an opportunity to express the nature of the client's business within the logotype while providing a freestanding symbol

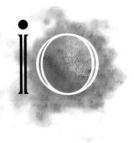

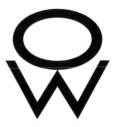

The symbols and stationery on this page share the common theme of flowers or plants. The waratah, the New South Wales state flower, became a familiar and stylish symbol for Grace Bros, a chain of department stores operating only in this state. The waratah appeals to the many women who frequent the stores without alienating male customers

The East Gippsland Shire Council was formed after the amalgamation of five local councils. Utilising the geographic features of the area, the identity combines elements from the local environment to successfully communicate the growth and development in the region

The symbol for Primrose Textiles utilises the strong visual opportunities offered by both words. Whilst the primrose was obvious, when combined with the textile weave, it allowed the trademark to communicate the nature of the business as well as the owner's name

Raffles Square is a new shopping centre in Shanghai. Singapore-based DBS Land wanted a name associated with both Singapore and mainland China, so we felt it was also appropriate to utilise the traveller's palm, which has always been associated with the Raffles name. The identity was required to convey some of the excitement and vibrancy of retail shopping

Below: When the City of Melbourne set out to win the 2006 Commonwealth Games, there was a need to establish a strong, identifiable symbol to represent the bid. With Melbourne as the capital of the Garden State, a leaf was chosen as the appropriate shape, incorporating colourful graphics to make it more festive and relevant to the Games. Strong, vibrant colours combined with athletic and festive visuals give the trademark its distinct appearance

Opposite: The symbol, logotype and stationery for Gardener Press had obvious origins. By taking licence with the spelling and meaning of the name, we were able to graphically demonstrate the nature of the business and the quality of the product. Using four-colour botanic images, the stationery items became promotional pieces in their own right, while the logotype and symbol could incorporate gardening images where appropriate

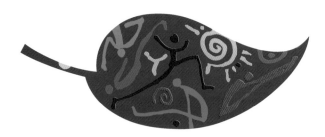

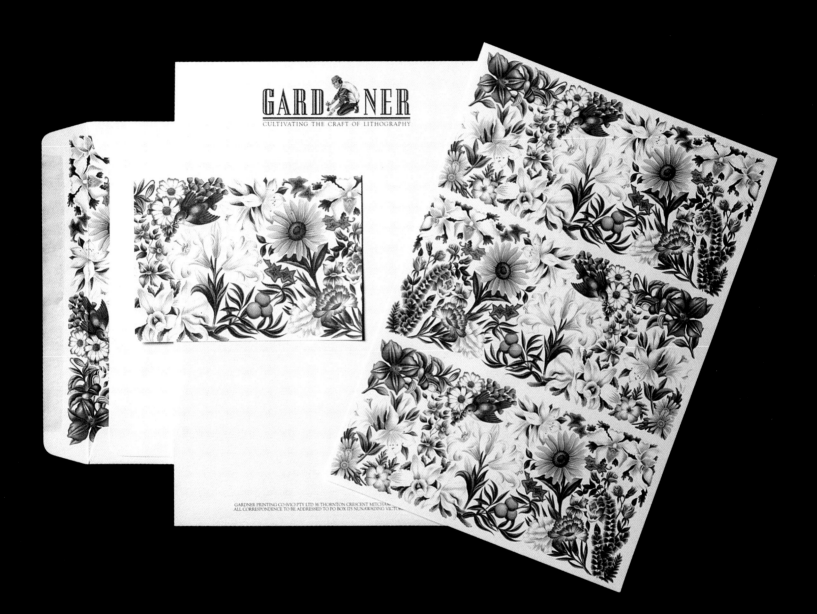

AGUA

CLUB & SPA

Villa del Sur

Environmental elements provided a symbol for the Wellington City Council's promotional needs. Although this trademark had a limited life, it was designed to capitalise on one of the city's most dubious features, its wind. While the city skies were mainly clear, the movement of the wind often unsettled the environment, and the constant movement that this created was a positive reflection of a city making progress

Ripples of water were used in a more simplistic and graphic form to become the symbol for South East Water, one of Victoria's suppliers of household water. The symbol can be found on service vehicles, signage and corporate stationery items

Below: Tasman Paper Recyclers transports newspaper between Australia and New Zealand. The company also successfully markets the recycled product in both countries. The symbol communicates what the business does and also how it does it

The natural elements have always provided great inspiration for the development of symbols. Water was the natural progression of an idea for Villa del Sur (opposite), a leading brand of mineral water marketed by Danone and Peñaflor in Argentina. In 1998 they launched their first club and spa. A new but familiar trademark was established through the inclusion of attributes of the existing brand

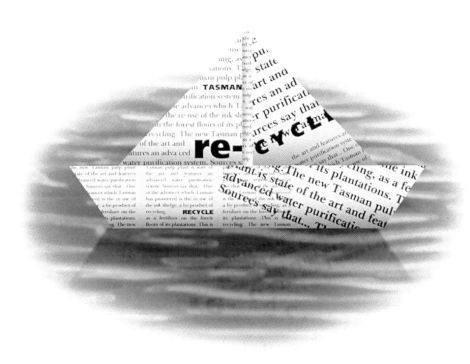

The newly formed Australian Academy of Design is a design school located in the Melbourne Docklands development. The dynamic ripples of water convey a sense of origin as well as outward expression and development. The relationship between the two ripples also conveys a sense of the relationship of learning

Sometimes the wording of the brief can prompt a simple way to the solution. When the Lend Lease group of companies wanted to establish a visual identity programme across all its individual organisations, the brief suggested that the different divisions should sit beneath the same umbrella brand

After undertaking numerous approaches, the final result (below) is an expansive blue canopy that is almost a literal translation of the brief

Diavolo, meaning devil, is the name of a pizza restaurant in Argentina. The idea for this identity was to utilise the circular shape of a pizza as the 'hole' and also incorporate the type as steam to complete the symbol

Golf Resorts International is a leading developer of golf courses in Australia and South East Asia. By combining traditional elements, the green, the hole and the ball, the identity (right) makes a strong and obvious statement about the organisation's business with a sense of simplicity and style

The development of trademarks for Mimi Japan/Australia and Miles Kyowa shared one common factor: both were partnerships in which both partners needed to be equally represented in the trademark. Mimi Japan/Australia (above) was a business developed by Mitsui and Mitsubishi, that was involved with exploration for natural gas in the Australian territories. The trademark alluded to a map of Australia combined with a natural gas flame, and both halves of the symbol represented the equal contributions of its two stakeholders

Miles Kyowa (below) is an industrial chemical company. As it happened, the initial letter from each corporation basically provided the same graphic form, and again they needed to be of equal size. The introduction of scientific symbols allowed the identity to be industry specific while retaining a strong, contemporary form

The symbol for the Snowy Mountains Hydro Electric Scheme presented an opportunity to reflect the attributes of natural energy production. When snow is melted by the sun, it provides the water for the generation of electricity. The symbol says it all

The privatisation of numerous gas companies led to many opportunities to identify the newly created organisations. Kinetic Energy supplies gas across the state of Victoria, and it was almost mandatory that the new symbol feature a gas flame because of its easy recognition. The name 'Kinetic' automatically suggests movement. Multiple images visually combine the source of energy, the specific industry, and demonstrate the name itself.
Opposite: The same movement of the flame also brought this recognisable shape to life. The unusual colour scheme for Westar provides further life, and gives an individual feel to something generic

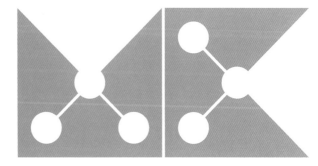

SUNCORP METWAY

4000 0012 3456 7890

4564

VALID
FROM 00/00 UNTIL
END 00/00 MONTH/YEAR

JOHN CITIZEN

SUNCORP METWAY

4000 0012 3456 7890

4564

00/00 MONTH/YEAR
00/00 V

JOHN CITIZEN

VISA

The amalgamation of Suncorp and Metway Bank brought together two of Queensland's most powerful financial forces. The combined organisation needed to make a statement about its increased strength and dominant position

The sun has been the basis of many symbols throughout history and we needed to find ways of making the trademark instantly recognisable and unique to Suncorp Metway. The rising sun combined with the tropical green of Queensland provides a distinct symbol that positions the organisation in the finance sector

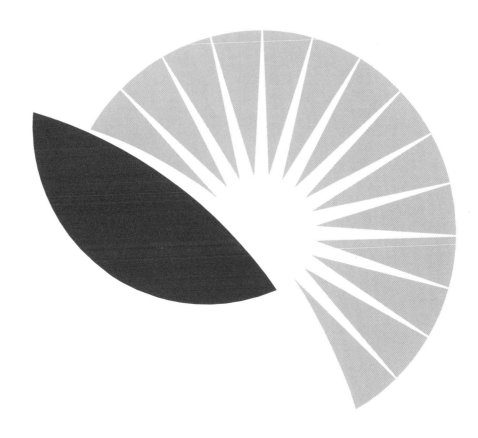

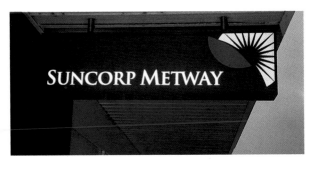

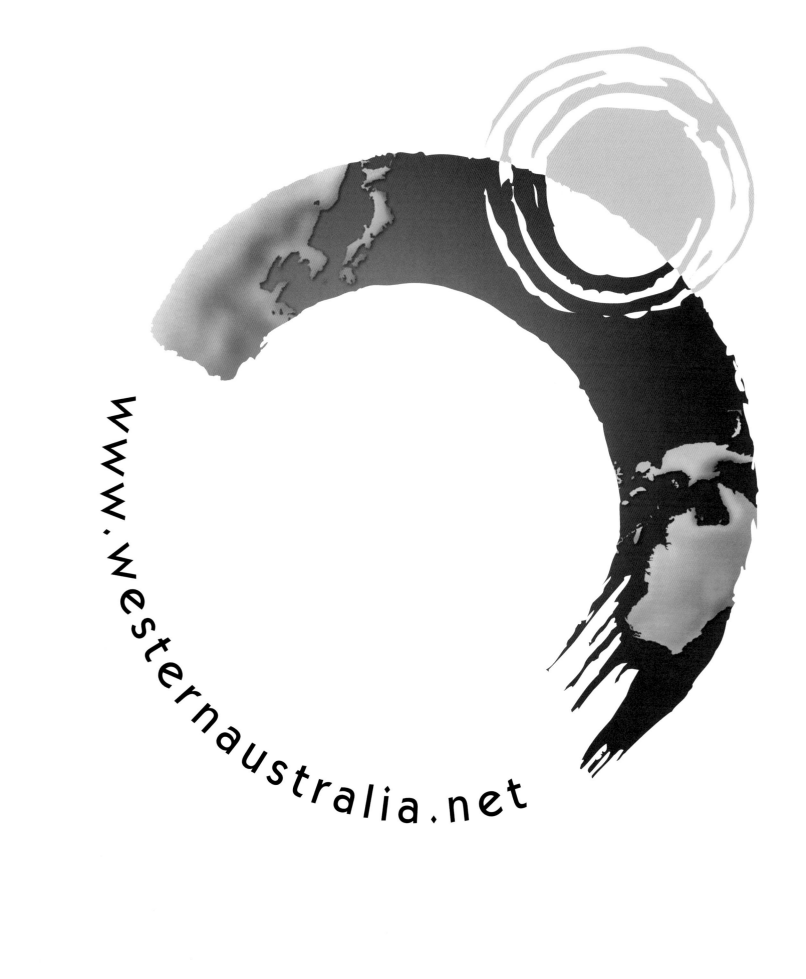

www.westernaustralia.net

The development of a brand to represent the new-found position of the state of Western Australia required a symbol that reflected the state's essence and personality. Given the diversity of its activities and attributes, it was very hard for one symbol to say it all

Ultimately a huge blue sky and the sun were used to convey an impression of the freshness and openness that is found in the state's canopy of blue sky and wide horizons. These two elements became the backdrop for other symbols, and it allowed the business, tourist and arts activities to be proudly displayed

The identification system appears on numberplates for the state, was included in its website (opposite), and featured on all tourism and promotional activities for Western Australia and its capital city, Perth

Some three years later we were briefed to develop a symbol for tourism in Queensland, a state previously known as the 'Sunshine State'. While this feature was not necessarily exclusive to Queensland, it is a more accurate description of this state than any other in Australia. We worked on developing a 'sun' and a recognisable graphic treatment that could be extended beyond the symbol. These qualities became part of the typography for the state brand, as well as communicating key messages connected to its climatic attributes

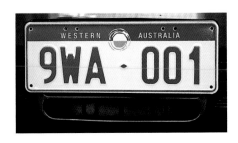

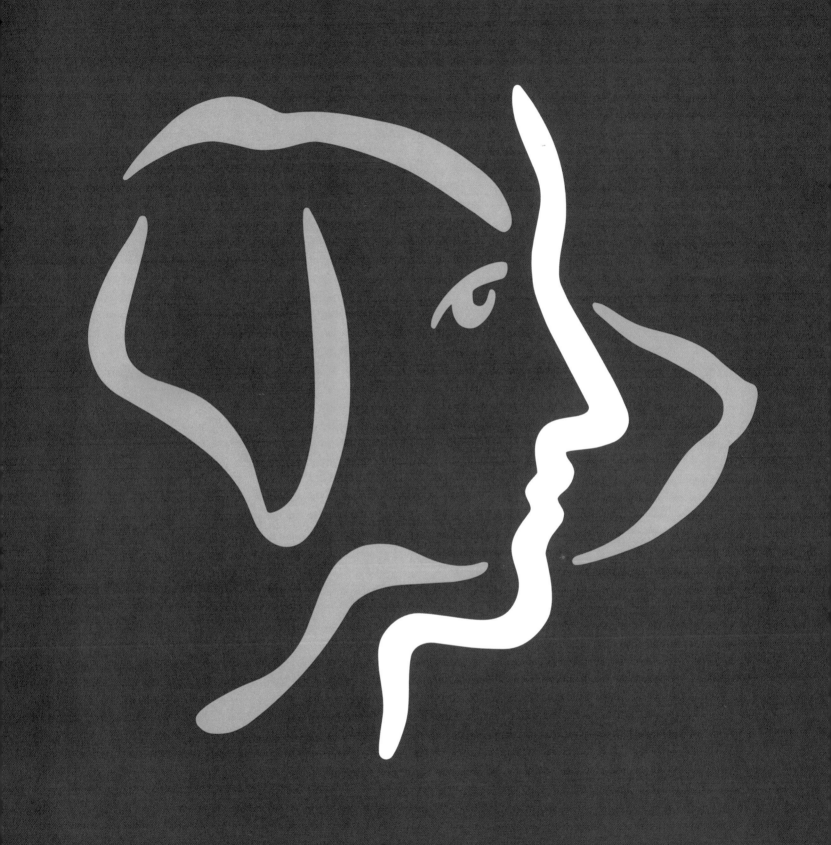

One of the most understood symbols for us all is the face, and our uniquely identifiable features allow each of us to be recognised instantly. It's perhaps not unusual to use this same device as a symbol for organisations and corporations. Opposite is the symbol for the Royal Guide Dogs Associations of Australia. The idea of combining the human profile with that of the guide dog simply conveys the desired outcome of the organisation's activities

The traditional theatre mask has existed for many years, in numerous forms. Our original concept for the Melbourne International Festival identity was based on this mask and its potential to evolve and change as the Festival progressed. With each Festival, the symbol was slightly adjusted to take on a different personality that reflected the events of that year's programme

The original symbol was simple enough that it became an easy and highly effective way of creating an identity for each particular Festival. Some years after the introduction of the original symbol, we redeveloped the form to combine two faces indicating the interaction taking place within the Festival

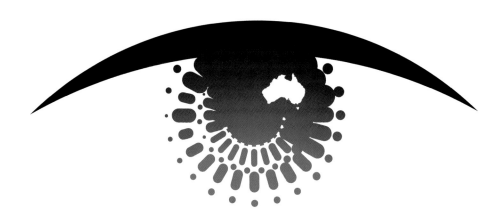

The World Blind Union Assembly is held every four years. We were asked to create an identity for the Australian Year 2000 conference that did not rely on symbols traditionally associated with blindness. The result is an eye made up of abstract figures in differing sizes combined with a map of Australia

An initiative of the New Zealand Ministry of Research, Science and Technology, 'Foresight' emphasises the need to be prepared for the 'knowledge revolution' and the changes it will bring. The idea was to emphasise the human element rather than technology. Using simple brush strokes, the identity (above) alludes to the project itself, and is a dynamic and adaptable identity

Over the years we've been involved with the design of many hotel restaurants, including The Borneo Pub, part of Dusit Inn Balikpapan in Indonesia. The local culture and the indigenous artforms were adapted to create a unique logotype and dramatic three-dimensional sign for the venue

When T'Gallant, a Victorian winery, introduced a big bold Pinot Noir, its strong bouquet was immediately noticed. Prompted by the wine's big nose, Cyrano (below and opposite) became the obvious choice for the name, and the inspiration for the label design

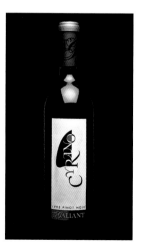

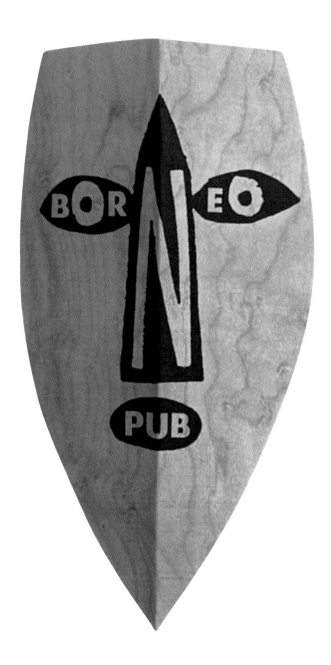

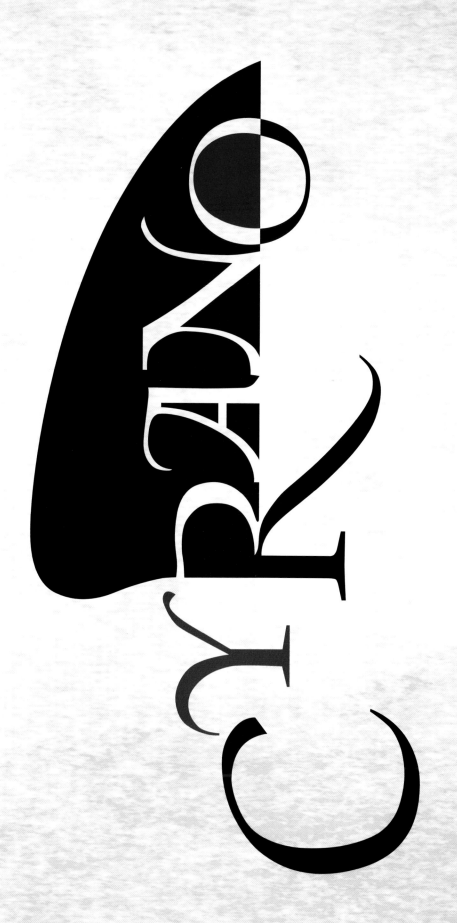

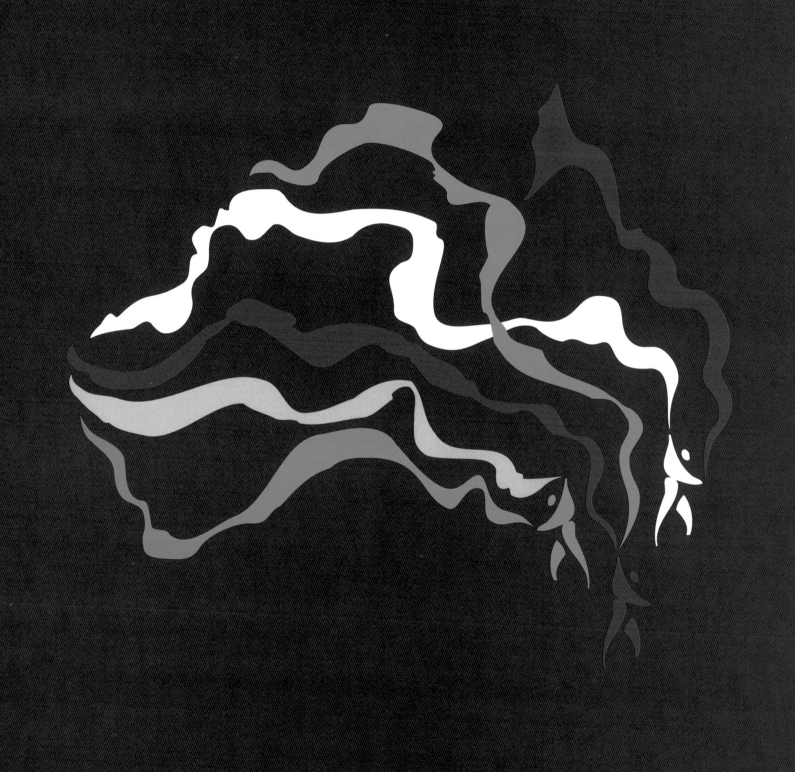

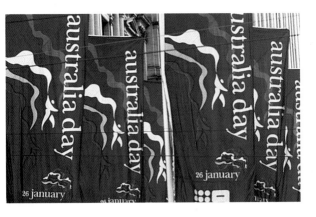

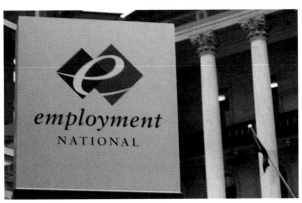

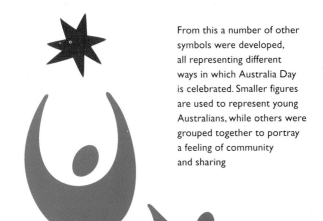

From a designer's point of view, the map as a symbol would seem to have fairly limited potential, except as an instantly recognisable device. However, in the context of Australia's cultural diversity it provided the appropriate basis for the Australia Day symbol

From this a number of other symbols were developed, all representing different ways in which Australia Day is celebrated. Smaller figures are used to represent young Australians, while others were grouped together to portray a feeling of community and sharing

Employment National is a nationwide initiative to increase employment opportunities. The organisation needed a distinctly Australian symbol which provided an opportunity to develop a vibrant abstract identity based on the map of Australia

Australian Medical Enterprises provides a variety of health care services. There was a need to demonstrate the link between the organisation and the medical profession. This came through the development of a more contemporary identity based on traditional symbols of medicine

The symbol for Clinica Bazterrica, a private hospital based in Buenos Aires, needed to communicate the concept of rehabilitation in a caring environment. The graphic brackets convey a sense of security for the patient during a period of recuperation

Schein Bayer is a world leader in the development of pharmaceutical products. The simple shape of its tablet product became the foundation of the corporate identity and the packaging design. The soft curved form is used to form an abstract letter 'S' to represent the company

This elliptical shape is used to create a grid pattern on various forms of product packaging, successfully communicating the product as well as establishing a stylish and contemporary identity for the company

Creating a symbol for the important subject of breast cancer brought unique challenges. As always, the direct approach seemed to be best but it had to achieve the delicate balance of strong communication with discretion. The identity for the Sydney Breast Cancer Institute shows a breast and at the same time alludes to the method of testing

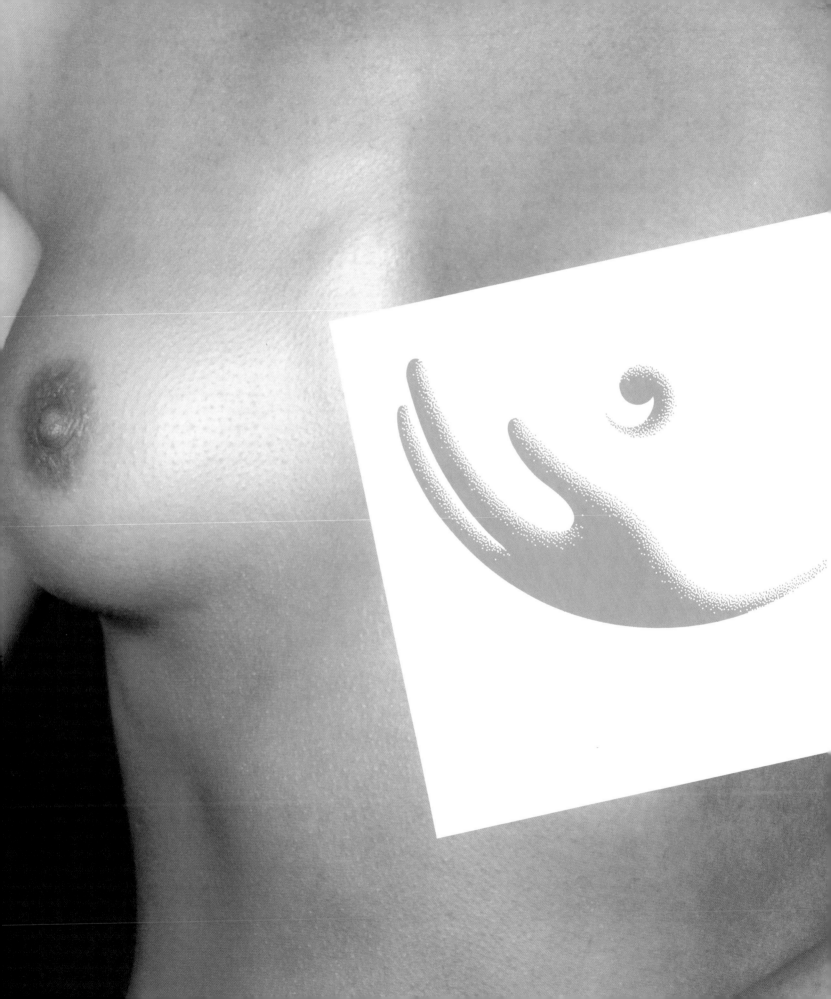

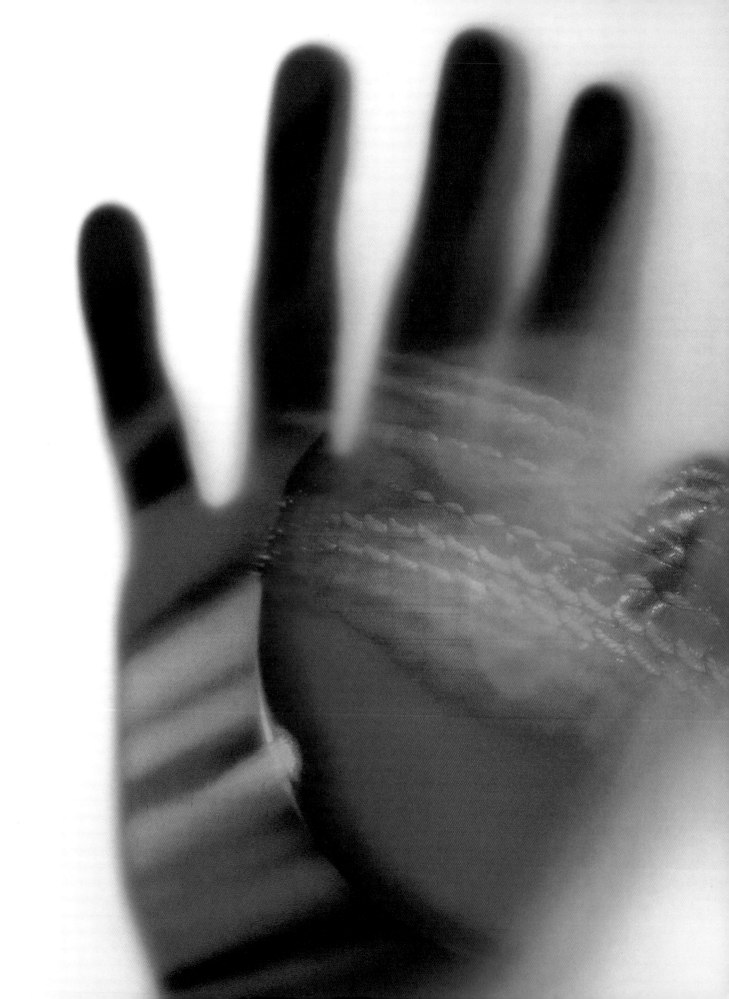

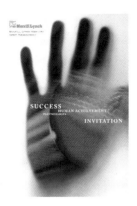

Each year Merrill Lynch
Mercury Asset Management
holds a promotional event,
known as the Roadshow.
Based on the theme of human
achievement, this image of
a hand suggests the personal
link between hard work
and success

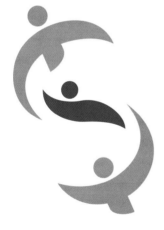

ChildSupport needed an
identity that would establish
the organisation's aims of
prompting financial support
from parents. Looking beyond
traditional representations
of the necessary elements,
we were able to combine
the dollar sign with the
human element by using
abstract figures

The human hand is capable
of an amazing number
of expressions that make
up a unique language.
The symbol created for
The Right Hand, a corporate
communications company,
featured a moving hand
to indicate the services and
assistance provided to
their clients

The familiar symbol of the
hand adapts to many positions;
therefore, instinctive gestures
and positions become the
focus of the communication,
while the graphic style
remains consistent

Meaning 'building with hope',
the symbol developed for
Reconstruir con Esperanza
incorporates the warmth
of the sun and an image
of helping hands to suggest
the assistance given to flood
victims in Argentina

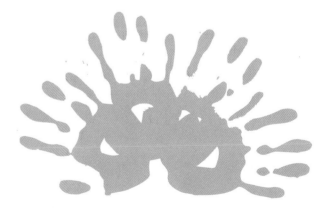

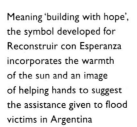

The development of the heart symbol meant that the name Deep Fire could be literally interpreted and simultaneously express the emotional involvement and commitment essential to any creative endeavour. This symbol also opened up myriad animation possibilities. The beginning of each video sees the screen burn away from its base, allowing the first frame to appear underneath. Unusually the scorch-mark of the heart appears on stationery follow sheets instead of the symbol itself

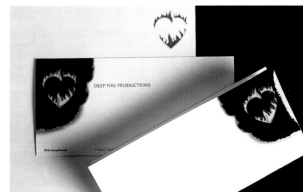

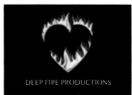

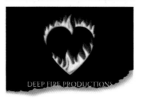

Occasionally the literal translation of an exotic word provides the basis of surprising imagery. Surabaya, when literally translated, means crocodile and shark. While there are numerous and memorable wildlife symbols that are used in the development of identities, the use of these creatures is unusual as they represent one of the Hyatt Regency holiday resorts

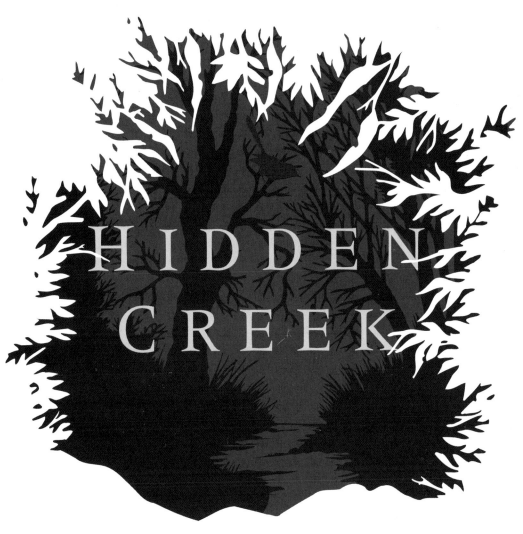

HIDDEN CREEK

The Mycal Bears are a Japanese football team. While it might be assumed that the bear mascot would be aggressive or ferocious to reflect the nature of the game, its interpretation was clearly that of a softer friendlier bear, more appropriate to the female teenagers who were the main purchasers of products displaying the team's mascot

Hidden Creek is a small vineyard in south-eastern Queensland. Tucked away in the region's granite hills, the quiet and tranquil location was the inspiration for the label design

Singapore's famous Jurong Bird Park experienced a dilemma in selecting one bird as a symbol for the tourist attraction. The choice was so immense that finally only a single wing was used. This was representative of all birds and allowed the use of existing corporate colours

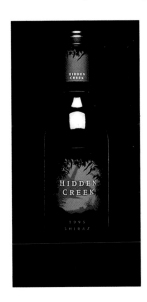

When Fini Group, a West Australian-based property development company, approached us to develop its new corporate identity, we saw the opportunity to create something that was distinctly different from a typical symbol. The company's different business divisions each required its own identity whilst visually remaining part of the Fini Group

The development of a Broader Visual Language was inspired by the Bower bird, native to the area in which the company is located. This bird is also known as Nature's Builder because of the intricate nests that they construct and their sensitivity to the natural environment. Each divisional identity features a different 'nest', reflecting the company's diversity and communicating its point of difference in the building industry

The Sunbird is native to Queensland and the name reflects the state's weather and its existing tourism symbol. It seemed appropriate to utilise the bird as the symbol for Aircraft & Marine Services, a company that offer charter flights throughout the state

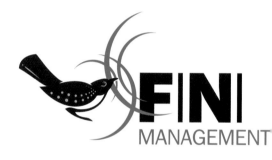

FINI
MANAGEMENT

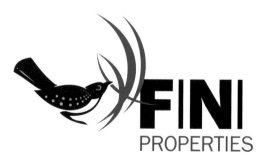

FINI
PROPERTIES

Using a familiar Australian symbol always risks banality, so making it specific to the subject is essential. For 'Design Down Under', a book featuring the best design work from Australasia, it was appropriate to use a symbol associated with the region that would be meaningful around the world

The familiar square, circle and triangle symbols of design were made appropriate when a kangaroo was constructed from these basic design forms. This was then incorporated into the Call for Entries, and the book cover and section headings

The natural movement of the kangaroo allowed further adaptation of the symbol as an animated feature. The symbols were positioned on the outside edge of each page so that the reader flicking pages would see the kangaroo hop as the pages turned

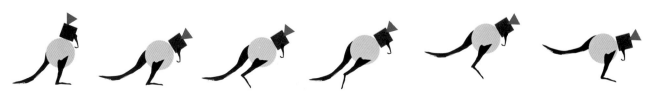

(down under)

SYDNEY
Super
Dome

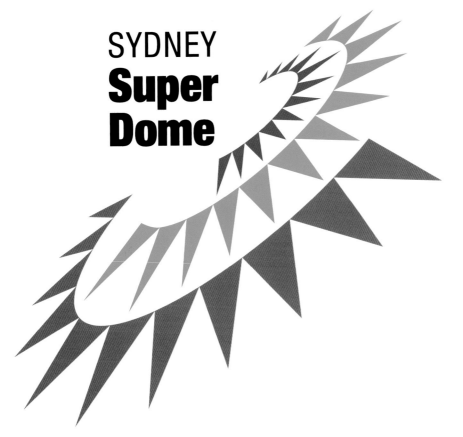

Symbols that are based on building forms can be highly appropriate, particularly if the building is a landmark or one of significance. The distinctive pointed forms of the internal and external tile patterns of the Sydney SuperDome provide the basis of a strong identity that is directly related to the architectural finishes

They also provide a direct sense of movement and energy appropriate to the activities that take place in the venue. The same graphic forms have been extended to create a friendly character that directs patrons around the centre and to simply provide a sense of activity and theatre

The spire of the Victorian Arts Centre is a significant and recognisable part of the Melbourne landscape. To capitalise on its presence, a simple two-dimensional interpretation of the spire would become the symbol for the Centre

However, the slender and elegant nature of the structure allowed for little impact if the spire form was reproduced in a small scale. This was overcome by using the negative space on either side of the spire to allow it to sit on a blue night sky portraying the corporate colours as well as those used for the illumination of the structure

The Burswood Hotel is part of a casino complex in Perth, Western Australia. The distinctive form of the building itself is combined with the idea of its tranquil location and water features to create an identifiable corporate symbol

Elewaut Perez

Sometimes we have the opportunity to develop identity programmes for companies with whom we have already worked

The identity for Elewaut Perez, the accountant for our Argentinian office, is based on the idea of incorporating numerals within his name to symbolise the working relationship. Quite simply, he's the man who handles our numbers

A conversation with my hairdresser resulted in the development of his trademark. As he cut my hair, I saw the pieces form a pile at the base of the chair

This simple idea saw me returning the compliment by doing the same thing to the name of the salon. The salon name, Stass, is present on the illuminated sign outside his premises, while the pile of letters appears at the base of the salon's street-front glass window

The activity of an airport, and different aircraft arriving and departing, formed the basis of the Sydney Airport identity

Sometimes personal and professional gestures provide a source of inspiration. The symbol for the Victorian Symphony Orchestra (above) found its origin in the movement of the conductor's baton, while the flamboyant initial letter of John Truscott's signature (right) gives a personal touch to the symbol for the John Truscott Foundation, an organisation formed in memory of one of Australia's leading theatre-set and costume designers

STASS

HAIRDRESSING

STASS

HAIRDRESSING

HAIRDRESSING

Apart from Christmas cards, one of the more difficult tasks for a designer is producing a trademark that represents the design profession and to then have it accepted by your peers

For the Sydney Design 99 Conference it was impossible to ignore the opportunity to utilise the quotation marks to replace the '99' component of the statement. This was interesting graphically, and it avoided the banal and obvious design-related symbols while providing a way for the symbol to be appropriate and present in all communication

It allowed each word statement, each speaker, each product and each activity to pictorially stand alone and still retain emphasis through the use of the quotation marks while including the event symbol

The letters ARC were just another set of initials, but through the introduction of the question mark they allowed the Applied Research Corporation to not only state its name but indicate the type of business they operate

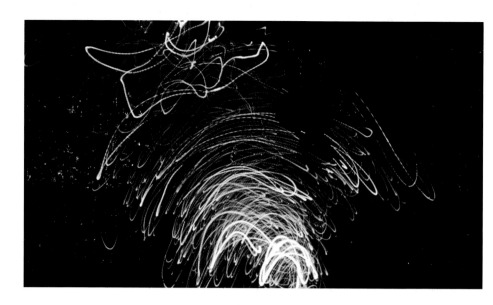

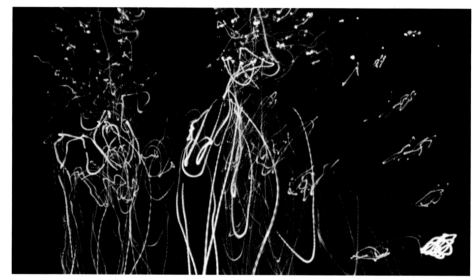

In the years leading up to the Sydney 2000 Olympic Games, the Darling Harbour Authority holds a series of vibrant, outdoor festivals

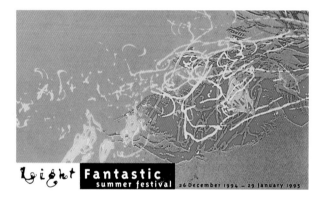

In developing identities for two of these, we interpreted the names of the festivals which are derived from the concept of light. We constructed our graphics by photographing the movement of small lights in a darkened room. The photographs on the right provided the graphic content for our printed material while identifying the festival with a unique graphic style

The deceptive art of looking like a symbol

The following pages are full of imposters. Graphic style passing itself off as a trademark. It's not that they are weak forms of corporate identification; in fact, it could be argued very much to the contrary. It's more that they don't fit neatly into the usual specifications of a simple trademark. They break some of the rules, and often break all of them. Few of them have a form which meets one simple definition that would allow them to sit comfortably amongst other very neat corporate trademarks ■ So, when is a symbol not a symbol? Sometimes the answer is blurred. Sometimes the graphic style of the communication becomes so potent that it performs like a symbol rather than adopting any particular single form. Or the deception can occur through the use of multiple symbols or devices that in reality only represent one organisation, or its divisions or its product. So pervasive is this method of presentation that it leaves the impression that a trademark exists, and, although hard to define, it also creates very strong brand recognition. The method of identification skirts the boundaries of Broader Visual Language in foundation, although it doesn't necessarily include the structural systems to give the same extension and flexibility as the more extensive concept

Light
Fantastic
summer festival

Light
Fantastic
summer festival

Light
Fantastic
summer festival

MEDIA RELEASE

Light Fantastic summer festival

Light Fantastic summer festival

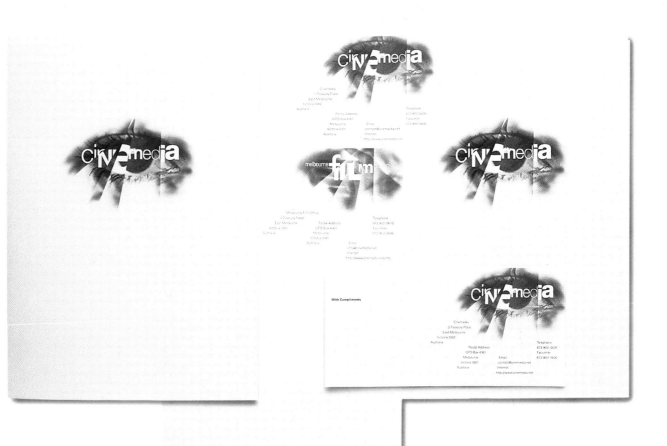

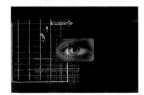

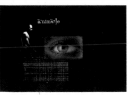

While film is the artform of the twentieth century, the new millennium sees the silver screen becoming a computer screen. Cinemedia promotes and assists the production, distribution and exhibition of screen content and culture for entertainment and education. Cinemedia builds on cinema heritage and the promise of new media and new ideas. Given the differing nature of the material that it handles, finding one identity to represent all of this presented us with a challenge. The two consistent components of these mediums were the use of light and the idea of movement. We devised a format that would allow different images and different words to be incorporated into a graphic structure. While each division is freestanding, they can still be seen as part of the same organisation

As part of the restructuring of its rail passenger and freight service, New Zealand Rail adopted the name Tranz Rail. In order to increase awareness of the restructuring and strengthen the organisation's marketplace presence, it was imperative that Tranz Rail be seen as one brand while differentiating the individual services the organisation offered. The 'Tranz' prefix and the blue panel act as consistent elements, while the various divisions are represented graphically

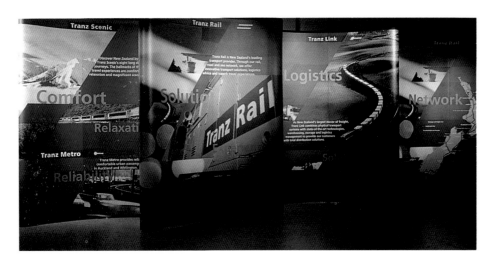

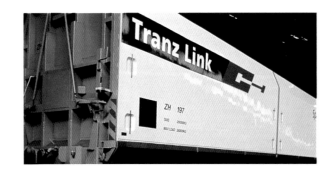

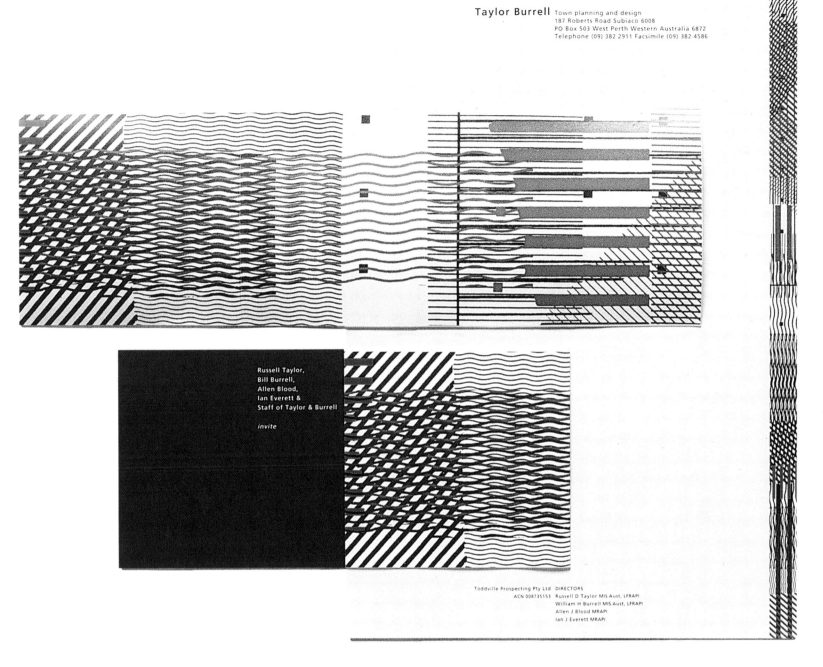

Taylor Burrell Town planning and design
187 Roberts Road Subiaco 6008
PO Box 503 West Perth Western Australia 6872
Telephone (09) 382 2911 Facsimile (09) 382 4586

Russell Taylor,
Bill Burrell,
Allen Blood,
Ian Everett &
Staff of Taylor & Burrell

invite

Toddville Prospecting Pty Ltd DIRECTORS
ACN 008735153 Russell D Taylor MIS Aust, LFRAPI
William H Burrell MIS Aust, LFRAPI
Allen J Blood MRAPI
Ian J Everett MRAPI

Taylor Burrell are leading
architects and town
planners. It made sense
that, in developing a new
corporate identity for the
firm, we should consider the
linear structures found in
their plans. These drawings
provided a range of colours,
textures and structures
which created a highly
recognisable presence
amongst the more
conservative identities
that dominate the
architectural profession

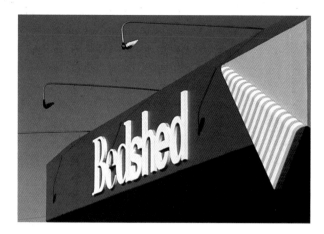

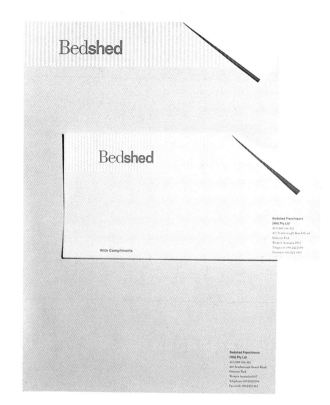

The simple act of turning over the corner of a made bed unified a warehouse full of beds displaying manchester of different patterns, textures and colours. This simple identity also allowed BedShed's main product to become a symbol in its own right

Extending the concept to pre-creased stationery, swing tickets and the building structure turned the familiar practice of making a bed into the main characteristic of the identity

Today, sophisticated sports diets enable top athletes to gain the extra something that leads to peak performance. Sports Dietitians Australia is an organisation dedicated to the research and development of high-performance diets

Together with major food producers, Sports Dietitians devises eating programmes that support optimum performance

In a distinctive illustrative style, the identity shows specific combinations of products from the right food groups in combination with the appropriate sporting activity

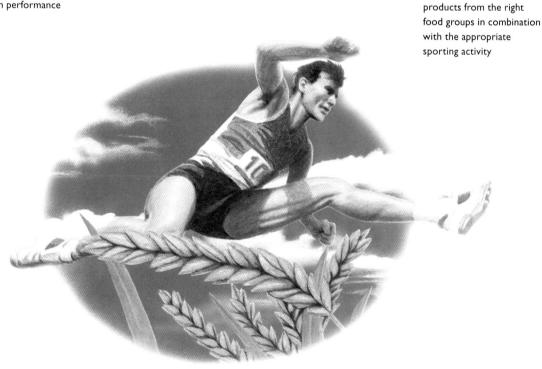

SportsDietitians
AUSTRALIA ACN 075 825 991

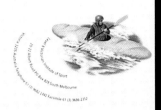

Level 8 Victorian Institute of Sport 20-22 Albert Road PO Box 828 South Melbourne Victoria 3205 Telephone 61 (3) 9682 2442 Facsimile 61 (3) 9686 2352

SportsDietitians
AUSTRALIA ACN 075 825 991

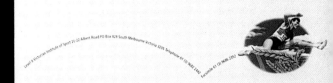

Level 8 Victorian Institute of Sport 20-22 Albert Road PO Box 828 South Melbourne Victoria 3205 Telephone 61 (3) 9682 2442 Facsimile 61 (3) 9686 2352

SportsDietitians
AUSTRALIA ACN 075 825 991

FUELLING FITNESS FOR THE FUTURE

Level 8 Victorian Institute of Sport

20-22 Albert Road PO Box 828 South Melbourne Victoria 3205

Telephone 61 (3) 9682 2442 Facsimile 61 (3) 9686 2352

SportsDietitians
AUSTRALIA ACN 075 825 991

Level 8 Victorian Institute of Sport 20-22 Albert Road PO Box 828 South Melbourne Victoria 3205 Australia

Telephone 61 (3) 9682 2442 Facsimile 61 (3) 9686 2352

SportsDietitians
AUSTRALIA

FUELLING FITNESS FOR THE FUTURE

Louise Burke
BSc Dip Diet PhD FSMA
Executive Committee

Level 8 Victorian Institute of Sport 20-22 Albert Road PO Box 828
South Melbourne Victoria 3205, Telephone 61 (3) 9682 2442 Facsimile 61 (3) 9686 2352

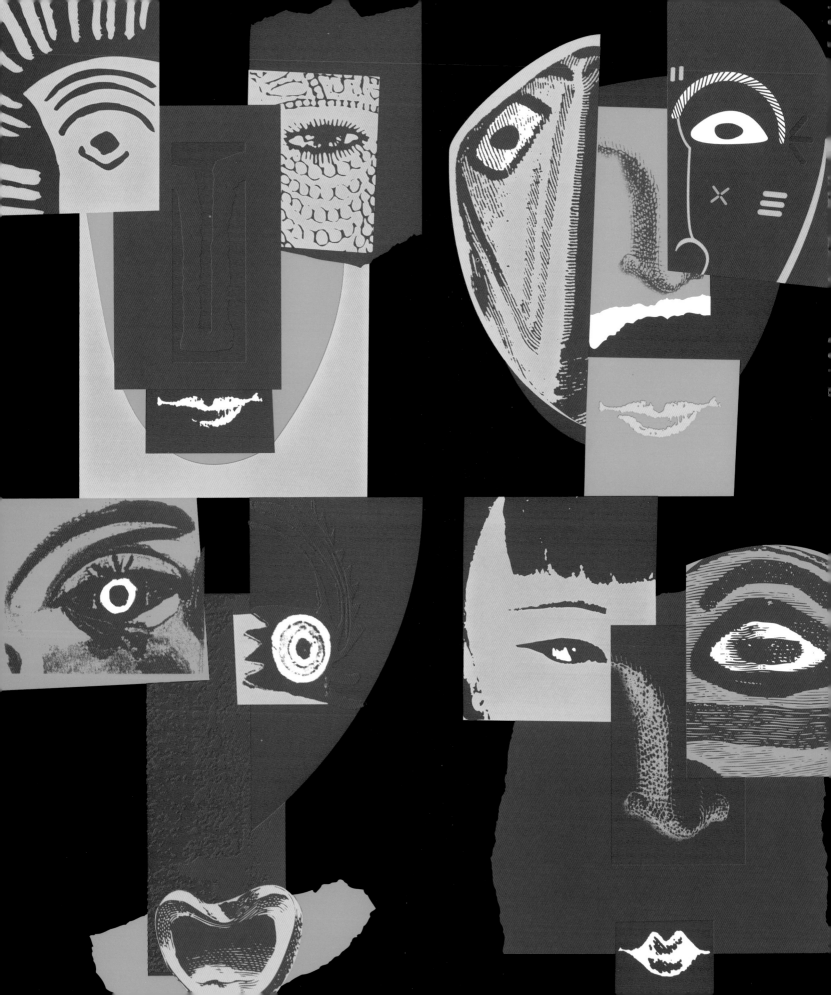

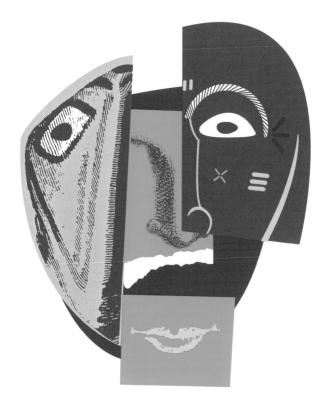

The artistic styles of many different cultures provided a rich source of information in the development of the identity programme for a multicultural arts programme called 'Kulcha'

Various facial features were combined in a collage style to create a number of single-head graphics

While only one symbol was used as the main focus for the organisation, it could never encompass the numerous nationalities participating in the programme

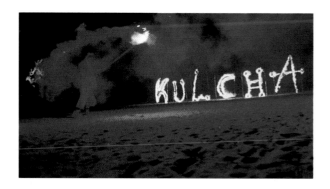

At the launch of the identity, the logotype was constructed on a beach and set alight in an exciting demonstration of the unique approach the organisation takes to performance art and multiculturalism. Combined with live theatre, the evening was a memorable introduction to a strong and distinctive identity

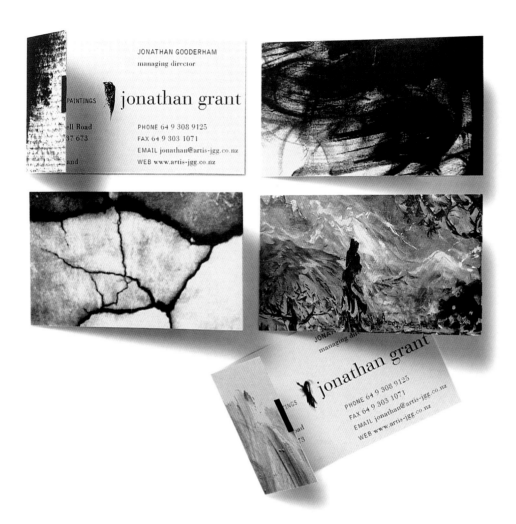

JONATHAN GOODERHAM
managing director

jonathan grant

PHONE 64 9 308 9125
FAX 64 9 303 1071
EMAIL jonathan@artis-jgg.co.nz
WEB www.artis-jgg.co.nz

Jonathan Grant Galleries specialises in European art for the New Zealand market. The concept was based on the Gallery's desire to enhance their marketplace positioning using a strong and consistent identity

Opposite: When the Singapore-based Metro department store saw the need to open a store targeting the teenage market, the 'Zone' concept became the ideal solution. The identity was based on the black and white patterns found on a television channel that is not transmitting. The designs were applied to all forms of packaging, while the store signage utilised four large-format television screens. Each screen displayed one of the four letters by means of an animated videotape so that the name appeared above the store entrance in a continually changing form

Located in Wellington, New Zealand, Starfish is a cutting-edge fashion store that designs and sells its own range of clothing. With an aggressive marketing style that reflects current social issues, the identity reflected the company's dynamic approach and alludes to the origins of its name

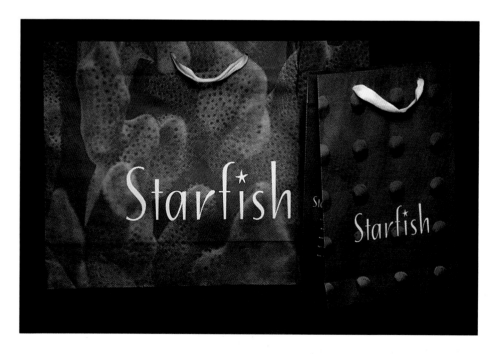

THE SUPPLY CHAIN

1300 658 856

The one consistent element of any supermarket purchase is the barcode. New Zealand's leading wholesale supermarket supplier, The Supply Chain, wanted an identity and name that reflected its actual operations. The barcode was interpreted in different ways to represent the activities of the company's various divisions

Above: CapitalLiquor is a wholesale liquor distribution company. In creating their identity, the barcode identified the company's link with retail operations

The barcode also appeared in the identity for the Waste Management Committee of the Auckland Regional Council. Used in conjunction with a scribbled mark that represents the used material, it clearly communicated the importance of recycled packaging. The campaign's primary symbol also utilised the scribble as part of the U Prevent Waste recycling programme

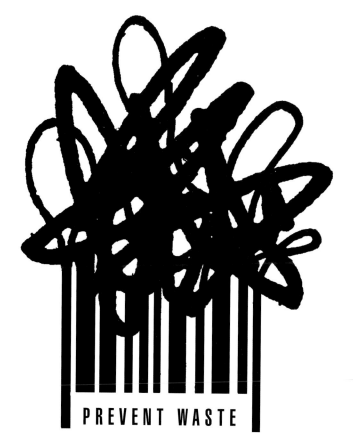

PREVENT WASTE

The obvious through different eyes

We have all experienced a situation where we have believed that a number of people have been given exactly the same information, but the actions or communications following this have proved otherwise. For a designer this phenomenon is not uncommon. But for the designer, the combination of different life experiences and an alternative viewpoint of the translation of business information, allows them to often restate the obvious in a surprising, compelling and effective manner ■ Some corporations and brands experience a stage when they believe they exist in a unique situation. This is no longer typical, as these days 'unique' is really 'unique'. While the situation is different for each organisation, the same set of circumstances has often existed in many other businesses. Therefore, it would appear that there is nothing new to say. Restating the obvious becomes the task, but it must be done in a distinct fashion so that the communication has impact and a life of its own, and the message conveyed largely appears to be new. The fastest way to communicate is often a direct statement of what is already understood. This information must be put into the context so that the correct message can be sent. It's largely about balancing what is instantly understandable against what is sufficiently different to be memorable, and it is the designer's role to understand the ingredients that give the message its strength rather than simply conveying the message itself. Hopefully the following examples will not so much surprise in terms of their content as leave a strong impression through their graphic interpretation

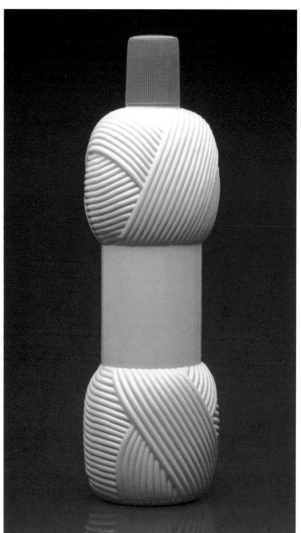

This package clearly tells the consumer what Prize is. By adding a cap to the familiar ball of wool, the complete package communicates the use of the liquid wool wash product while providing a protected flat surface to carry the label and brand name of the Nicholas Kiwi product

Opposite: In the lead up to celebrating the new millennium, the China International Art & Design Expo commissioned a series of posters from some of the world's renowned designers. Our idea was simply to show a package containing celebration materials together with the familiar 'use by' date sticker

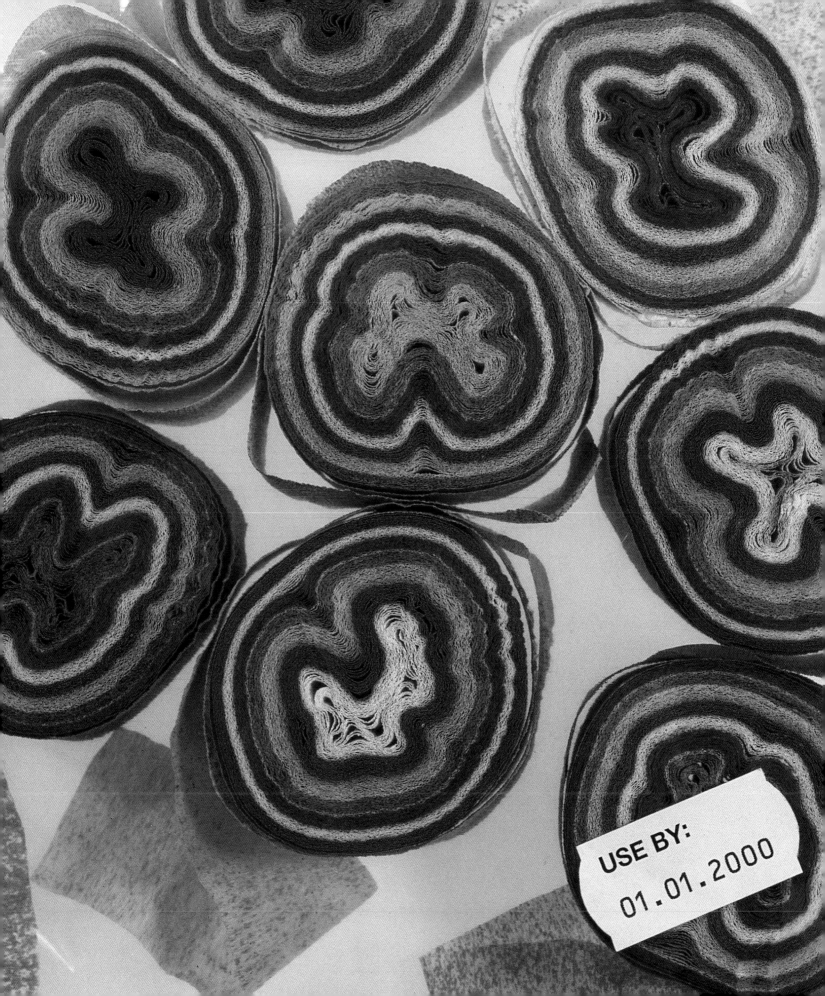

USE BY:
01.01.2000

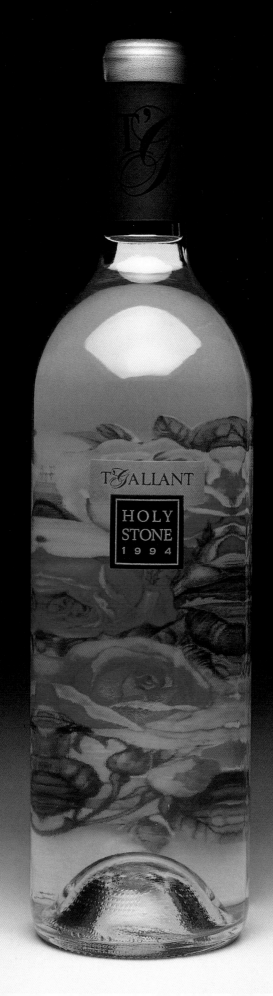

T'Gallant, a boutique winery on the Mornington Peninsula, has pioneered many different grape varieties and wine styles. Amongst these is Holystone, a wine of a distinct pink colour that was obscured by the original brown glass bottle (near left). In order to capitalise on the wine's attractive appearance, we substituted a clear glass bottle. To draw further attention to the wine's colour, we placed the main label on the back of the bottle, demanding that the consumer look through the rose-coloured wine. The small front label isolates and highlights the brand name

The see-through properties again became a feature of T'Gallant's Demi Vache, a dessert wine, that is sweet and syrupy, and not for the diet-conscious: a point that is not lost on the discerning eye viewing the label from the back of the bottle

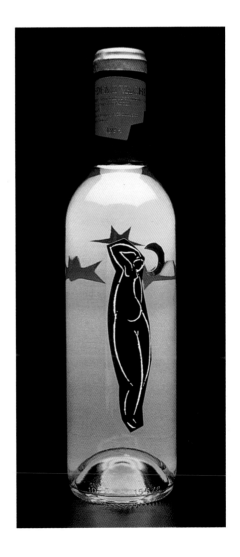

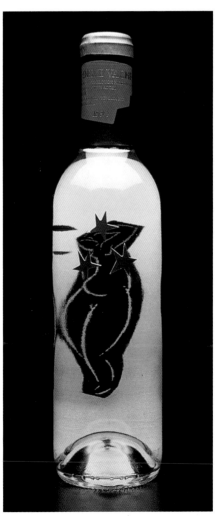

Like so many wineries, T'Gallant produced a wine that carried an art series label. While repeating a familiar industry concept, it was essential to execute it in a new format. We ultimately decided to emphasise the vertical nature of the bottle and the artwork. Integrating all the packaging components was essential to the final presentation of the product, which sharply contrasts with the more traditional horizontal art series label that is more commonly utilised

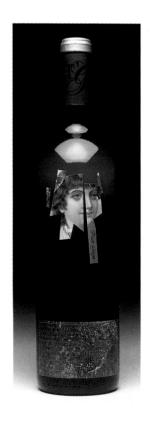

T'Gallant has always been prepared to dare to be different in their winemaking and in the way that the product has been packaged and marketed. For the second Pinot Grigio of the season, a Bin number seemed appropriate but no specific number came to mind. Ultimately, KK01 was created. Kevin and Kathleen, the winemakers, provided the initials, and 'O1' simply meant 'other one'. The italianate style of the label reflects the heritage of the grape variety

When T'Gallant converted an apple orchard to a new vineyard, the first vintage was named after the lot number of the new address. A traditional stencil used to label the apple crates provided inspiration for the front label, while the back of the package carried a stencilled '2'. The colour of this number changed with each vintage, as did the residue of colour around the stencil

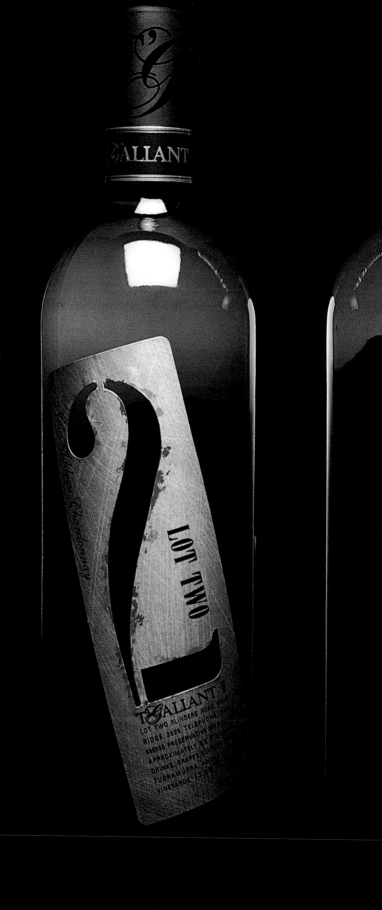

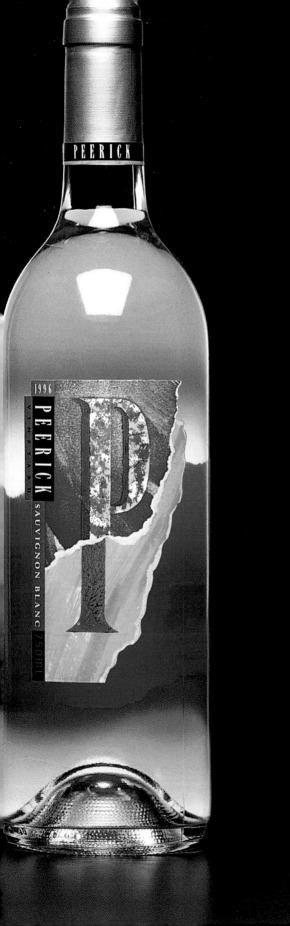

It is most unusual for a wine to have a map as the main feature of its brand but, because of the obscure name and location, it was the perfect solution for Peerick wines. Not only did the label provide information for the knowledge-hungry wine buff, but the distinctive label and bottle design sharply contrasted with competing products

Birds and animals related to points of origin inspired the main visual content for the packaging on this page. The bird of paradise, which appears on the New Guinea national flag, immediately identifies the product's point of origin. While it was an unusual symbol for Robert Timms coffee, it was more unusual to see it used several years later on beer packaging for South Pacific Breweries. Originally based in New Guinea, the brewery had just been awarded the prize for the world's best beer, which presented a great opportunity to utilise their premium quality product to develop an export market, particularly in the United States

Companies from the Australian state of Tasmania, home of the legendary Tasmanian Tiger, are sometimes forgotten completely in the domestic marketplace. When Tasmanian Breweries decided to launch a beer to compete with the major breweries on mainland Australia, establishing a strong marketplace presence was imperative. The Tasmanian Tiger created a distinct brand identity, immediately identified the source and established a distinctly different approach to beer packaging

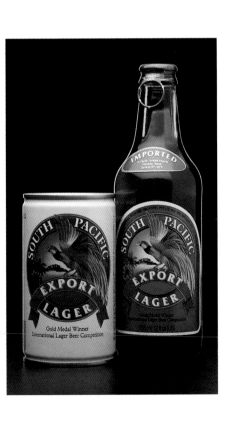

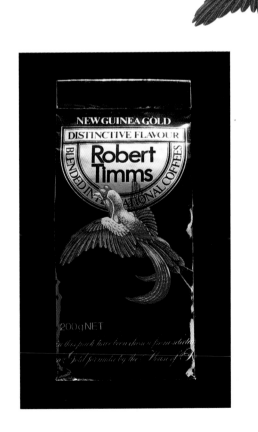

When Melbourne decided to bid for the 1996 Olympic Games, a short-term communication programme was required as part of the bid formalities. The first step was to convince Victorian residents that the city could stage the Games, and more importantly to convince voting members of the International Olympic Committee that Melbourne was the city in which the Games should be held

As the 1996 Games would be also celebrating the centenary of the event, we felt that the bid symbol should be something directly related to the Olympic Games; something instantly recognisable which would communicate successfully in the condensed time-frame. The Olympic Flame and Olympic Colours became the beginnings of a Broader Visual Language based on Olympic sports icons

These icons were reproduced in different formats, including large sculptures that were part of a much larger plan to decorate the entire city. Hoardings around Melbourne's major construction sites were used as promotional opportunities, while the freeway entrance to the city featured strong colour statements related to the main identity

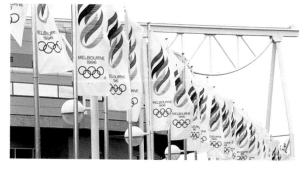

MELBOURNE
1996

NAIL
LACQUER

BY
poppy

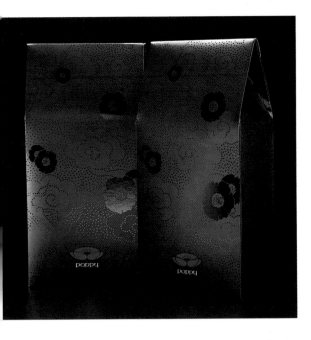

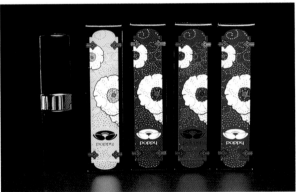

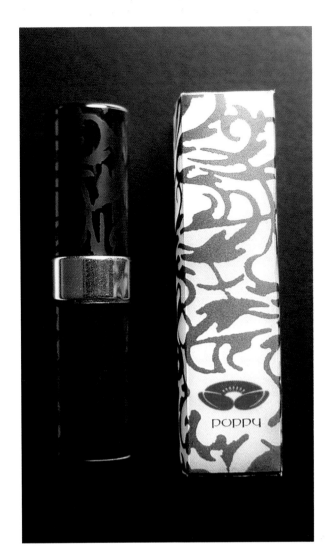

There are times when it's impossible to avoid the obvious. With a love of art deco and art nouveau styles, and a name like Poppy King, the question was simply how to develop the identity for an international brand range of cosmetics and lingerie. The now familiar red Poppy symbol provided a simple and direct means of establishing the brand. Other forms of the flower were developed as graphics for packaging, point of sale material, merchandising and sales concessions

In developing the symbol for Scienceworks, we considered elements of activity that suggest both the intellectual nature of science, and the change of state that occurs in scientific experiments. The combination of various materials transforms an expression of the building's architecture in conjunction with the industrial nature of the site to create a unique signage system that reflects the dynamic nature of scientific endeavours

Often the answer to the problem is in the project ingredients. When Australia's own BHP moved to a new city building, we utilised the corporation's own product materials and original geological rock strata drawings as the content for their building signage

As a result, the signage not only delivers directional information but provides an insight into the corporation's activities. It's appropriate, informative, and it reflects the architectural integrity of the building

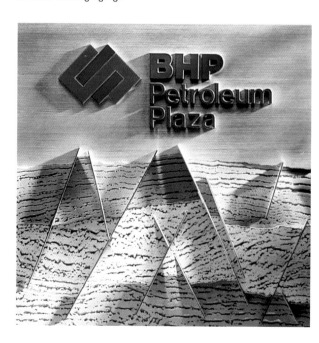

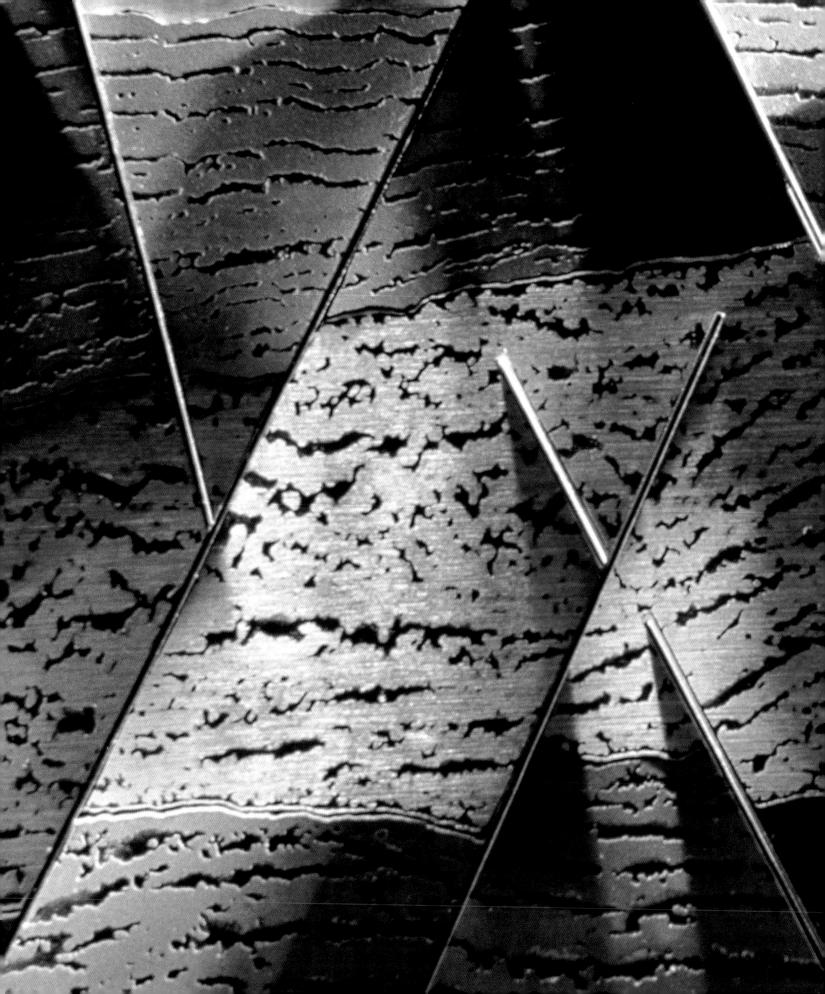

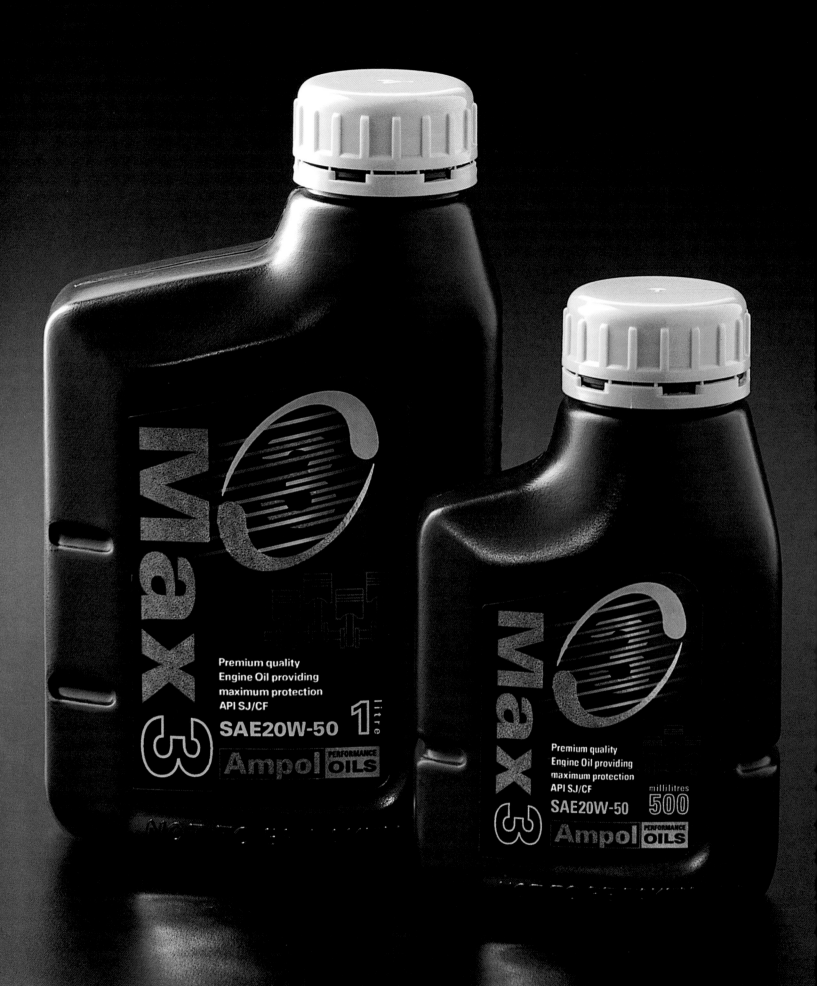

The rebranding of the Ampol range of products became an opportunity to utilise an oil drop as a device that communicates the product as well as its usage across all collateral material. We used the free-flowing shapes that oil naturally takes to break the format of square-finished pictorial images

Using the colour black created an industrial feel while acting as a visual link between the packaging and promotional items. Matt finished brochure covers contrast with the high-gloss look of the oil, providing a strong visual reinforcement of the product and the Ampol brand

Below: ScreenSound Australia is one of the leading cultural institutions specialising in restoring and archiving the nation's historical audiovisual material. The identity was based on traditional elements of television, cinema and radio. The megaphone and the film reel conveys both the visual and sound components of the media

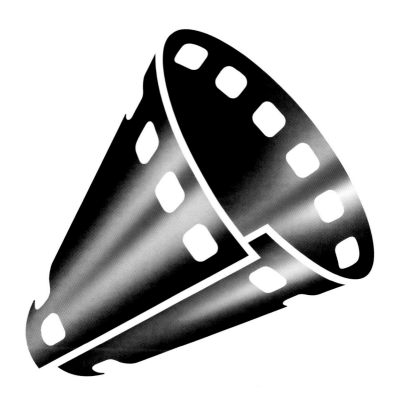

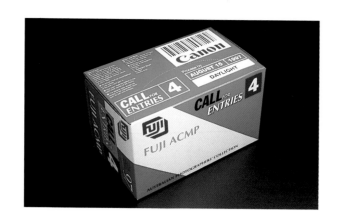

Open to professional photographers, students and assistants	**Do not send slides, transparencies, glass or framed pictures**	**Open to photographers who are citizens or residents of Australia**	**Closing date is August 15, 1997**	**Mount all photographs on standard 16" x 20" mount**

Australian Commercial & Magazine Photographers (ACMP) and their sponsor, Fuji, agreed with the idea of combining familiar icons from film packaging and camera instructions with completely different information. The Call for Entries for the fourth year of competition took the format of a Fuji film package, enhancing the sponsor's branding as well as providing the relevant information and entry conditions. Each year an Annual is designed to display selected entries to their best advantage

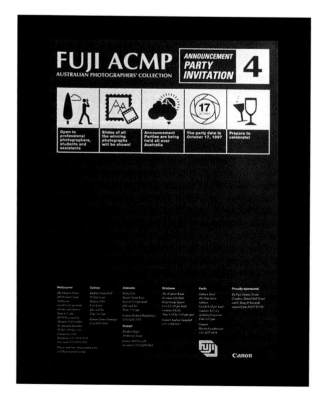

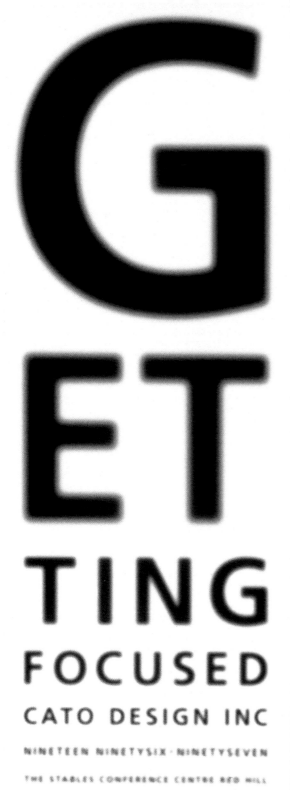

G
ET
TING
FOCUSED
CATO DESIGN INC
NINETEEN NINETYSIX · NINETYSEVEN
THE STABLES CONFERENCE CENTRE RED HILL

Prior to changing its name, Cato Partners conducted a weekend away for Senior Managers from its national and international offices. The objective was to better understand where the company was headed, focusing attention on the things that were really important to the development of the organisation. The invitation poster took the form of an optometrist's test sheet which was deliberately out of focus. At the conclusion of the weekend's events, attendees received a sharply focused version of the same poster

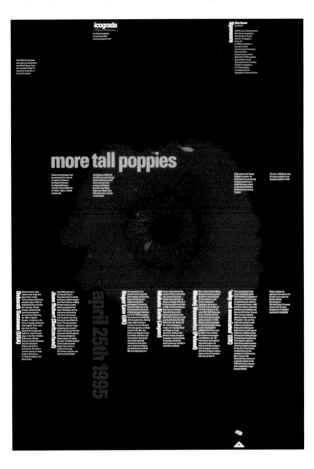

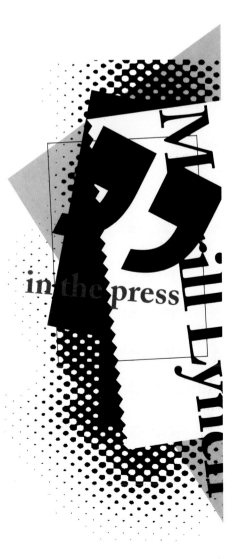

'In the Press' is a Merrill Lynch Mercury Asset Management publication that comprises newspaper articles from around Australia. The internal layout has the look and feel of a newspaper yet remains contemporary. A typographic treatment based on printing techniques was developed as an identity for the document

A group of international designers were due to deliver a series of lectures as part of the three-day AGIdeas design conference. As it happened, the engagement coincided with Anzac Day, a day of remembrance for armed services veterans in Australasia. A poppy is used to mark this annual occasion, and in the context of numerous international renowned speakers, pre-eminent in their fields, the concept of 'tall poppies' provided a relevant and striking visual opportunity. The list of ingredients for this project made the solution more than obvious

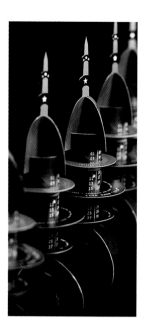

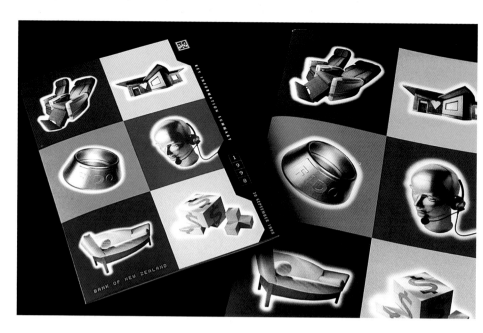

'The Rocket' is a staff magazine produced for the Bank of New Zealand. Drawing on imagery from the Bank's identity and its corporate philosophy of reaching for the stars, we incorporated serious articles into a more contemporary magazine-style layout. The energy and drive of the name is also reflected in the bright colours and different photographic styles

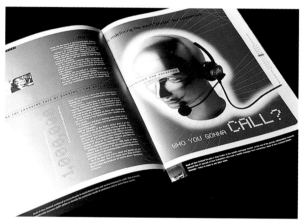

The Bank of New Zealand Annual Report had always been a traditional document, but the 1998 Report was to have a more contemporary feel. We were able to achieve this through the use of case studies, given a futuristic look using metallic and fluorescent inks to embellish the photographs of inanimate objects that comprised each case study

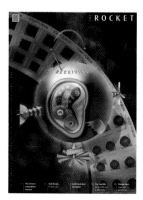
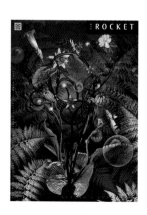
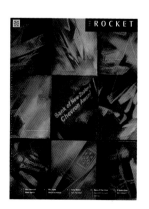
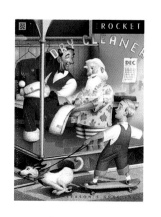
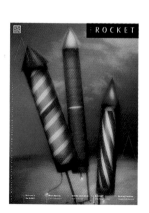

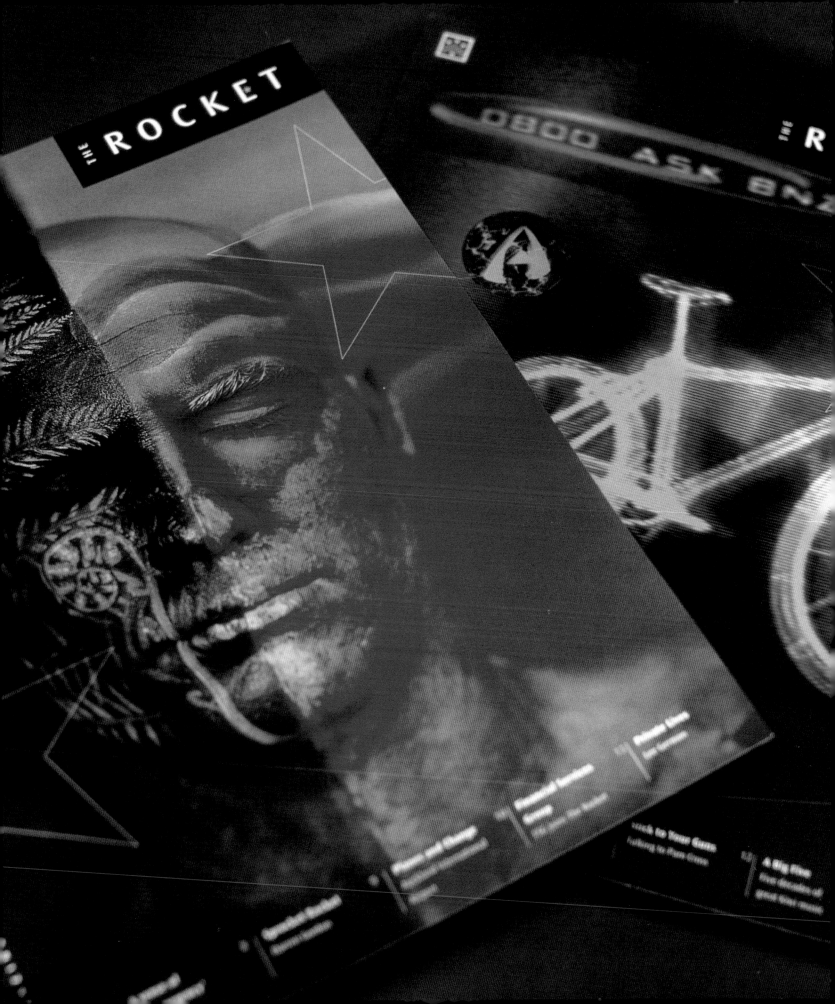

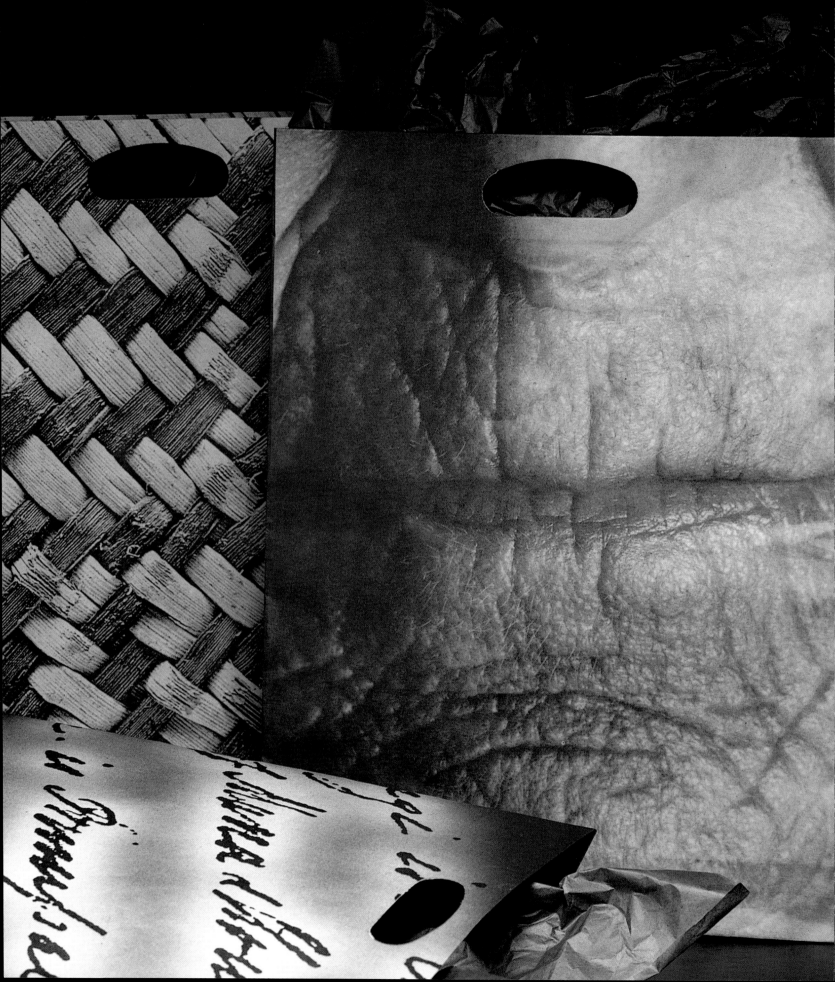

The National Museum of New Zealand was renamed 'TePapa', meaning 'our place'. The retail area of the venue needed a relevant but separate identity from the museum itself, and it also needed to communicate in a manner relevant to New Zealand culture

The concept went on to provide an expansive visual palette for communication. The photographic portrayal of writing, word of mouth, weaving and tattoo, drawn from traditional New Zealand story-telling, was applied to the interior of the outlets as well as the packaging

'Hindsight' is the title of another book in this series. This publication comprises a collection of thoughts from international designers in response to the most-often asked questions of students and followers of design. Looking back over past experiences prompted the concept of the turned-over eye. The simple translation of the idea into a symbol provided an interesting book cover and memorable title

Hindsight
Perspectives on
Graphic Design

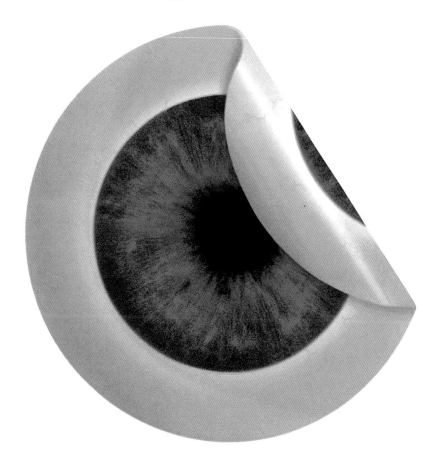

The concept of bridging the technology gap inspired the design of a more literal bridge made from various bitmap components

While this may seem a little obvious, the graphic forms provided a strong visual format that clearly identified the national presence of Australian companies and Australia as a partner country at the Cebit Exhibition in Hannover, Germany

The 'Intelligent Australia' theme connected the various components of the exhibit itself

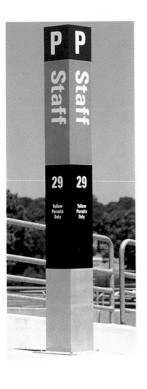

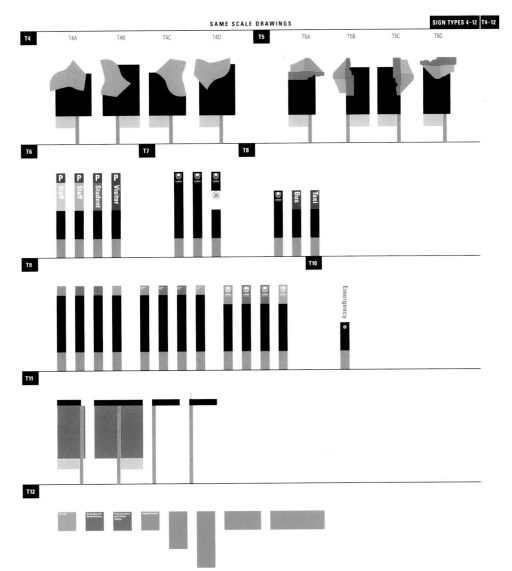

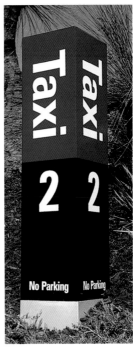

Above: Hierarchical structure of signage from side entrance to precinct, and from building to a specific room

Opposite: Entry signage orientates the site plan and locates the basic precincts

Any university campus is complex to negotiate, but few universities have the same luxury of space as Curtin University in Perth, Western Australia. The faculties have expansive facilities and extensive space contained within a cocoon of playing fields and parklands. The campus area is like a maze and the site has a number of entry points which can complicate simple directions. Basic communication was seen to be the most effective solution. A system of narrow totems was designed to accommodate concise messages. It was important to provide a signage system that was easily identified and accessible and which did not intrude on the landscape

The Westmead Children's Hospital site plan provided scope for artwork in the building's forecourt and surroundings. We were given the opportunity to demonstrate healthy activity in an environment of care and recuperation and we responded with a series of metal sculptures decorated in bright, clean colours. The structures add an element of hope and positivity to the entrance area of the precinct

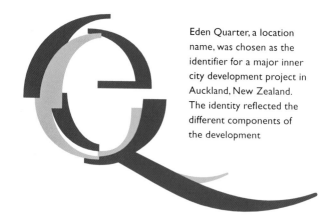

Eden Quarter, a location name, was chosen as the identifier for a major inner city development project in Auckland, New Zealand. The identity reflected the different components of the development

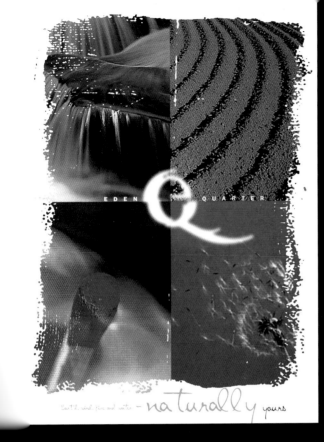

Part 2: wind, fire and water - *naturally* yours

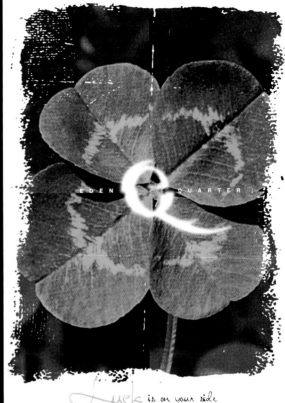

Luck is on your side

Theres something in the *wind*

Four seasons - Everyday *people*

Jose Luis Rodriguez is an Argentinian photographer. In the construction of his studio and many other elements of his life, there is the repetition of curved forms. These are present in his contemporary studio, in the background on which many of the photographs are taken, and in the lenses that are used in the execution of his work. This theme continued into the presentation of promotional material for his clients, as well as on the CDs that contain the digital images of some of his photographs

A marketplace in which all competitors seem to look the same offered the opportunity to create a strong national brand for milk. Pura Milk singlemindedly launched a range of products that incorporated the simple idea of a white splash of milk on a solid background colour

The Delivery Juice Company of Argentina saw an opportunity to enter the marketplace with fresh juices squeezed and delivered within five hours of production. What was needed was a natural way of differentiating the product. In the end, the freshness of the oranges was almost enough, but to bring it to life a three-dimensional leaf was arbitrarily applied to each package

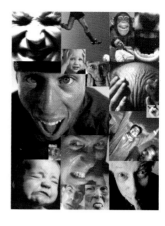

'Messenger' is a quarterly newsletter that Merrill Lynch Mercury Asset Management sends to its clients. Containing reports and updates on managed funds, and information about other products and services, 'Messenger' has to convey this material in an approachable format. This cover design accompanied a change to the company name, as it suggests that the newsletter had an important message to convey. Two speech bubbles, which are used to highlight important sections of the text, form the letter 'g' to create a visual link between the cover and the internal layout

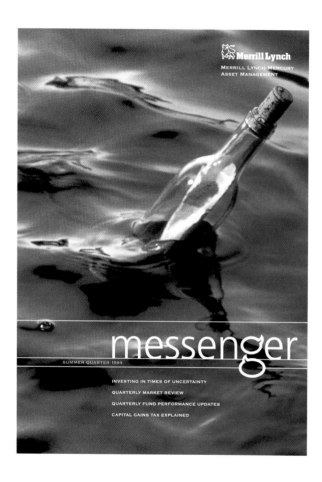

When photo library Imagebank was developing its new catalogue, eleven international designers were each asked to create a double-page spread to introduce different sections

For the sports photography section, we shifted the emphasis from the sport itself to that of the spectators' reactions. This provided the broadest possible interpretation, knowing that these reactions could be representative of any competitive sporting situation around the world

The DDD Gallery in Japan conducted an invitational poster exhibition for which designers from around the world were asked to produce a pair of related images. We chose to work with a die that is used to make sewerage pipes. A male and female form became a mechanism to express a natural relationship between the two posters

Looking sideways and seeing around corners

The obvious is always the obvious except when it's different. The majority of our clients have been intelligent and instinctive business people, able to articulate their problems and opportunities, and in most cases, the solutions to those situations. Most of our clients understand the message that needs to be communicated to provide an optimum result. But all too often it's so clinically defined that it's boring, or lacks the potency to be memorable or to create an indelible impression on the consciousness of the receivers ■ Lateral thinking is something that is quite often discussed but rarely practised. Looking sideways for meaningful solutions should always be within the peripheral vision of the thinking designer. It provides a different landscape of visual opportunity and for strategic thinking. It's one of the things that distinguish the business executive and the designer as business strategists. Looking sideways enables the designer to provide the unique twist or viewpoint to add an element of surprise to an idea and make it live in our visual consciousness

The images on this spread come from an identity programme developed for a new television channel in Argentina. The Azul name was chosen, which, simply translated, means blue. The channel's management was keen to have an animal or bird as their trademark

After struggling to find the right blue creature, we turned our thinking upside-down, producing a list of clearly defined creatures and objects that were obviously not blue which we then simply made blue. The visual disconnection created a highly memorable broadbased visual language suitable for all programmes as well as the main identity

The blue strawberry for the cooking programme, the blue egg for the breakfast programme

and the blue soccer ball for a sports programme made powerful direct statements, while allowing strong station identification without the need for a symbol, trademark or any other word or visual device

And our answer to the coloured bird or animal was a blue flamingo. Simply, the goal was to create a blue world that was recognisable anywhere

To help celebrate the Seventieth Anniversary of David Jones, one of Australia's leading department store chains, we were asked to wrap their entire Sydney building as if it were a giant present. There were several obstacles in achieving the objective

Not only could we not touch the historic sandstone surface of the building, but we had only four weeks to complete the task. Hardly enough time to devise a separate structure to go over the building, to complete the engineers' windloading tests, and to finish the construction in time for the celebration. Besides, we knew the idea had been used numerous times in different countries around the world

The number of windows also seemed problematic until we saw this apparent negative as the way to an achievable solution. Within the allotted time-frame we found images from seven decades of women fashion and used the external surface of every window of the building to convey our celebratory message

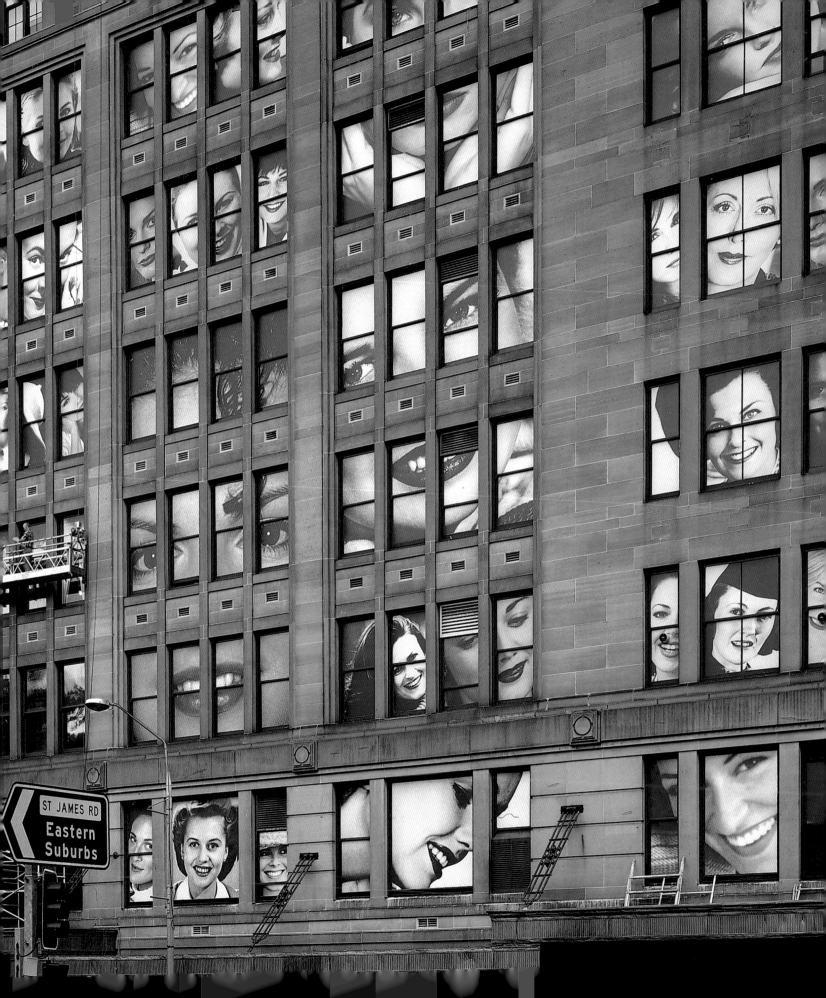

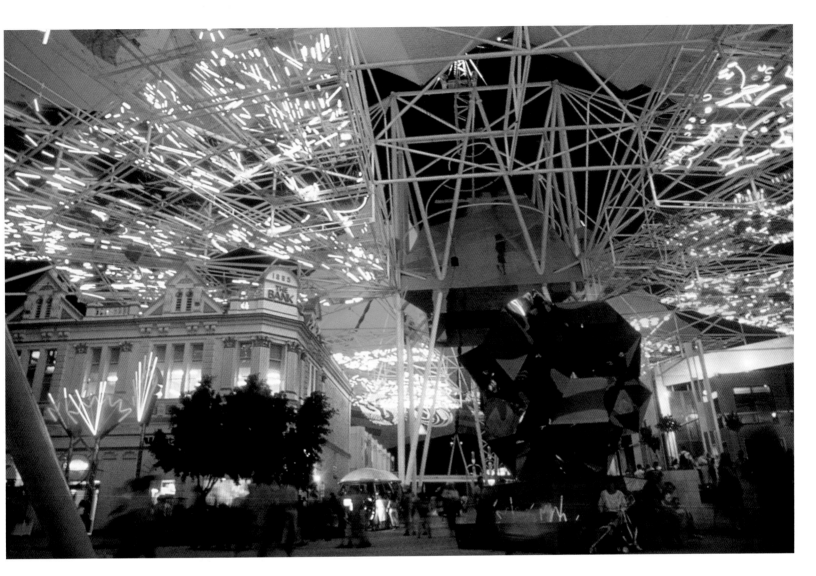

The centrepiece of World Expo '88 in Brisbane was an area named Time Square. While the organisers had seen this more in the spirit of its New York namesake, we thought the central meeting space could suggest the elements of time

Four thousand square metres of ceiling space and seven-and-a-half kilometres of neon tubing created a giant ceiling with three horizontal levels and one vertical plane of changing coloured light images. Each of the quadrants was themed by the four seasons

The art of making change without changing anything was the opportunity presented by Prime Life Corporation, one of Victoria's leading developers of retirement villages and properties

The old logotype (above) was redesigned to give greater emphasis to the two components of the name

Some refinements to the leaf allowed the creation of a stronger brand statement. The basic principles of the corporate identity allowed the introduction of individual themes for each property or village. Each sub-brand is unique yet still clearly part of a meaningful corporate family structure, establishing the beginnings of a Broader Visual Language for Prime Life

Riverwood

Cumberland View

Glendale

Koorootang

Established for nearly
fifty years, 'B&T Weekly' is
a magazine synonymous with
broadcasting and television.
With the growth of new media
communications, 'B&T Weekly'
now covers advertising and
marketing as well, and it was
decided to redefine the
look of the magazine and its
masthead. Initially, there was
some confusion amongst
the audience as to what 'B&T
Weekly' really stood for.
It develops new life by relating
the initials to the title of
each section within the
magazine and not just to the
broadcasting and television
worlds which they
originally represented

Urbane Publicity is
a specialist studio in Japan
providing high-quality
still life photographic
services. The idea behind
the presentation folder was
inspired by the studio's
clients, who often have
firm ideas about what they
want but only in their
minds. The perforated folder
reflects the process of
imagination. At first glance,
the final photograph is an
image of shape and colour,
only becoming a 'real'
image once it is removed
from the folder, in much
the same way that images
'happen' in the mind
before the picture is
photographically realised

name of the column related
to industry

the name for summarised
news items

BANTER & TATTLE

Brat pack

B & T WEEKLY

AdvertisingAge

VOL 46 |2076| $2.95

FRIDAY | MARCH 8 |1996

Games gold grab

James reigns

Cougar on the prowl

Gallucci for Watt

BRIEF & To THE POINT

BLARING & TUNED

BAGGED & TIED
ACCOUNTS MOVES

Mazda, Hilton turn Grey

FREE TIM SHAW

MODE

Bagged & Tied refers to
accounts under review or
accounts gained and lost

Blaring & Tuned became
the name for news and
interesting items related

DIA D

"EL ESPIRITU SANTO LES REVELARA TODAS LAS COSAS"

Te proponemos un espacio para: **encontrar** a Jesús en lo cotidiano, **contarnos** lo que el Espíritu Santo hace en nuestras comunidades, **descubrirnos** como hermanos, **celebrar** la alegría de la comunión, **dar** un testimonio de solidaridad, **anunciar** una Iglesia Joven que camina hacia el tercer milenio.

ENCUENTRO DIOCESANO DE JÓVENES · COLEGIO "JESÚS EN EL HUERTO DE LOS OLIVOS"

"El Espíritu Santo les revelará todas las cosas"

¿A quienes? chicos y chicas entre 13 y 25 años.

¿Cuándo? sábado 20 de junio.

¿Dónde? en el gimnasio del colegio "Jesús en el Huerto de los Olivos". Alberdi 1150 · Olivos.

¿Horario? desde las 14 hs.

Te pedimos que comuniques esto a tus amigos, que juntes y traigas alimentos no perecederos y que traigas imágenes del Santo Patrono de tu comunidad.

"Ponete las pilas para festejar el encuentro con Jesús y tus hermanos"

Informes: Casa Pastoral lunes a viernes de 17 a 20 hs. tel.: 747-5378 / 743-1306.

Organiza Pastoral de Juventud.

ASAMBLEA DIOCESANA · DE · JÓVENES

La Asamblea reúne anualmente a los representantes de la Pastoral Juventud (animadores, asesores, catequistas de confirmación y representantes de las comunidades de jóvenes y movimientos) para que compartan experiencias y preocupaciones comunes, busquen criterios, planifiquen objetivos y evalúen los procesos de la Pastoral. En la Asamblea 1997 se trabajará en cuatro talleres según los siguientes temas:

1 El Proceso de la Pastoral Juventud.
2 La espiritualidad de los jóvenes.
3 La educación de los jóvenes en la fe.
4 La animación de la "esquina".

Los participantes de la Asamblea podrán optar por participar en cualquiera de estos talleres. También habrá un plenario donde se presentarán las actividades para el próximo año. Se realizará en el Colegio Marín el sábado 15 de noviembre de 15 a 19 hs. Organiza el Equipo de Pastoral Juventud.

EN EL
NOMBRE
DEL
PADRE
Y DEL ESPÍRITU SANTO
EPRI

RETIRO PARA
JOVENES

PREDICA PBRO. GUILLERMO
CARIDE | DEL 19 AL 21 DE MARZO
EN LA CASA DE ENCUENTRO
DIVINO MAESTRO (SAN MIGUEL)
PARA MAYORES DE 20 AÑOS
INFORMES E INSCRIPCION
LUNES A VIERNES DE 17 A 20 HS
—EN LA CASA PASTORAL—
ITUZAINGO 90 | SAN ISIDRO
TEL.: 4 512 3851
EQUIPO DIOCESANO DE PASTORAL JUVENTUD

DEL
HIJO

The best known symbol
of Christianity was
graphically restated to
communicate specific
events in a contemporary
way to youth groups
of the diocese in
San Isidro, Argentina

Chile's second-largest exporter of wine, San Pedro Vineyards, released a premium late harvest dessert wine called Nectar. The sweetness of the product prompted the idea of using a paper butterfly as the brand identity. Made of plasticised paper and glued only by its 'body' to the bottle, the butterfly seems to have settled naturally on the bottle rather than appearing as just a printed image on a conventional label

Prospero is a wine produced by Vinifera Services in New South Wales. Inspired by a Shakespearian character's name, we wanted to bring something of the wise Prospero to the product itself. The label features pages from Prospero's books of knowledge which fall down the bottle to become an integral part of the typography

As a continuation of the corporate identity and store design programme for Coles Supermarkets, we developed the initial direction and foundation of packaging for the housebrand, Farmland. The different products carried the identity but also needed to be category or product specific in their communication. Here both packages clearly demonstrate the product use through the visual representation of simple and self-evident ideas

Farmland

90 FACIAL TISSUES 21CM X 19.5CM

The Australian National
University's Centre for the
Mind was established to
strengthen our scientific
understanding of what it is
to be human. We wanted
to create an identity that
reflected the intellectual
capacity of the Centre,
as well as communicating the
organisation's aims in a clear
and contemporary way.
The idea of the open square,
which suggests the ability to
think beyond parameters,
was the flexible concept
behind the Centre's identity
programme. The result
emphasises the scientific
nature of the Centre's
research without limiting
the visual expression to
traditional scientific elements

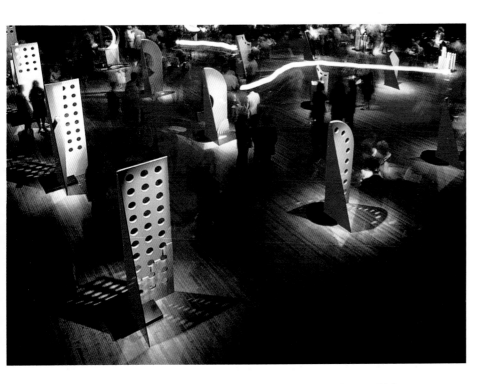

Each season, Laminex Industries launches its new range of building materials to architects and designers. In this particular instance, rather than the usual tradeshow, the company focused the exhibit in such a way that it demonstrated a commitment to the needs of the design profession

The invitation to the launch came in the form of a large three-dimensional poster that could be individualised. The sculptural nature of the invitation exposed a backing sheet that could vary in colour. The exhibit comprised twenty individual sculptures demonstrating the sixty-five new colours and finishes

Theatrical lighting was employed to add drama and a sense of occasion to the event. The display was also fully transportable, which allowed the range to be launched in a new city each day

When Australian singer James Reyne commissioned us to design graphics for his new CD, there were two potential titles. We created several concepts for these, and ultimately 'Design for Living', based on a song about people who occupy two houses, was chosen. One house is very design-conscious and built to impress others. The other house, next door, was the environment they preferred to live in when appearances didn't matter but the criterion was one of a more liveable environment

To demonstrate this, we used a simple graphic equation: a very contemporary, design-conscious coffee pot juxtaposed with a very comfortable and traditional willow pattern teapot. Plans and elevations of the object were used effectively on the outer packaging, the inner booklet and the disc itself

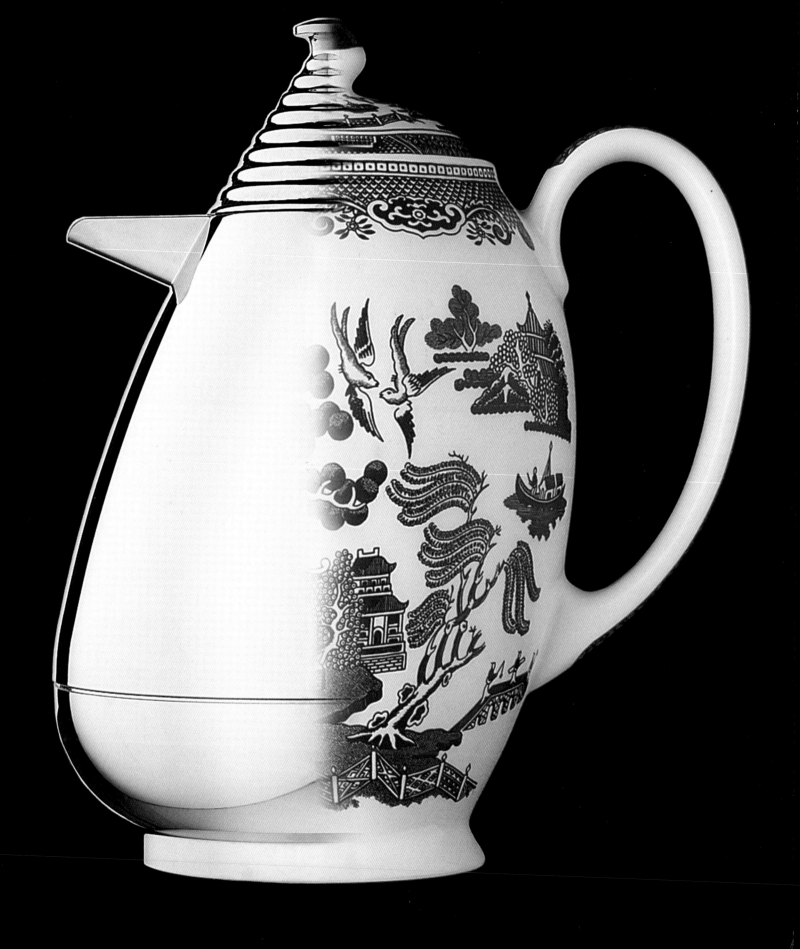

For The Mojo Group,
an advertising agency that
has grown and diversified,
a series of symbols
differentiated the services
offered through the Group's
different business divisions.
Based on the idea of the
Group wearing many hats to
suit the differing service needs,
each symbol contributes
to a collection which is the
cornerstone of the corporate
identity programme

M
O J O
GROUP

Nicholas Da
Managing Partr

The Mojo Grou
4-16 Yurong Str
Telephone 61 2
Mobile 0418 40

A traditional monogram, heraldic colours and colour fields underpinned the development of a range of fruit-based chocolate products for Three Hats. A traditional logotype and structure of typography complete the classic ingredients, while the packaging sits comfortably amongst contemporary products

The retention of significant historical elements contributed greatly to the development of a new range of premium beers for J. Boag & Son. The familiar figure of St George and the dragon, combined with the vertical elliptical label often associated with beer packaging, provide a traditional foundation for the new products

In Australia and around the world, Foster's is just another word for beer. Extending the tradition of the brand required the acknowledgement of the well-recognised and established brand identity components for the introduction of a new product, Foster's Extra. The creation of a new bottle shape brought new life and a distinct identity for this new addition to the family of products

The visual history of an organisation can be successfully adapted to communicate its future direction. Since 1956 the Seven Network branding has evolved to reflect changes to the organisation and to its programming. The figure seven has remained a constant although in many different forms. The introduction of colour transmission in 1975 prompted Seven Network to utilise the colour bar as a recognisable and positive identity, and the association with the colour red had always successfully conveyed a strong and dynamic message. Born out of the colour bar, the new identity comprises a trademark that rotates and folds across

the screen through the colour spectrum to finally form a red figure seven. Infinitely flexible, the new identity is an evolution from the previous 'broken seven' and distinctly different from other television station identities. The trademark also incorporates the other colours of the spectrum in applications such as promotional program breakers and outdoor signage, and is easily adapted to opportunities in new media.

the one to watch

After a two-year restoration period, Singapore's Raffles Hotel is once again the epitome of lavish colonial style. In developing new identities for the hotel and its outlets, we decided to combine the many period styles that had preceded our work

Hand-drawn alphabets and authentic manufacturing techniques were incorporated into signage. All it needs now is a little time to get old

Never ignore the obvious. In the development of outlet signs for the Acacia Hotel in Indonesia (above), it seemed sensible to speak in the same language as the source of inspiration for the venue

The Littore Group comprises five separate companies all involved with growing wine and table grapes in north Victoria. To reflect the heritage of the companies, we used a graphic style that is reminiscent of traditional wine labels and communications at the period of their establishment

After diversifying its strategic business focus, Rothfield Print Management needed an identity that reflected the change in its operations. We retained the script lettering from the original identity, and combined it with a linear structure that suggests the new emphasis on the planning and management aspects of the business

In creating the identity for Pomeroy Pacific, an Australian property development group, we wanted to reflect the nature of its business activities. We incorporated an art deco style with abstract block forms to create the illusion of a building seen from a different perspective

For Keystone, a company that provides corporate communications services, the basis of the identity was found in the name. The visual identity found its origins in stonemasonry and the traditional foundation stone

Stefano Lubiana is a family-run winery in Tasmania with a history in winemaking that goes back five generations. While retaining the heritage, there was a need to develop a contemporary range of packaging that would compete in today's marketplace

For over fifty years the condor has been the symbol for Aerolineas Argentinas. A native bird of South America was an appropriate choice for the airline's trademark

The bird's profile unfortunately emphasised the head, beak and neck, attributes that were amongst the worst features of the condor

The airline's new symbol places an emphasis on the large wing-span which identifies the condor as the world's largest bird in flight

To reflect the spirit of Argentina and its national airline, a cohesive Broader Visual Language was developed. Based on a rich history and diverse culture, Argentina's traditional art and craft techniques were adopted in the design of woven fabrics for aircraft interiors, and a similar tapestry look has been continued in the design of tickets, baggage tags and other print material

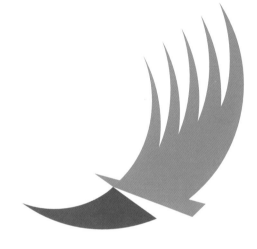

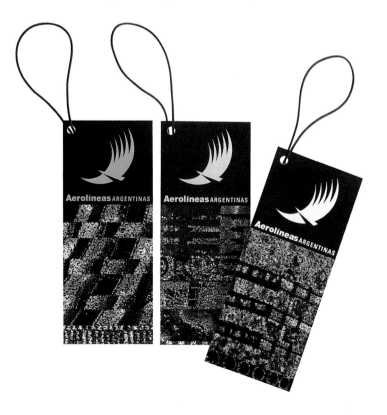

Normans Wines was founded by Mr Jesse Norman in the early years of the colony of South Australia

NORMANS WINES EST·1853

Normans Wines Limited
ACN 007 206 484
Website
www.normans-wines.com.au

HEAD OFFICE
Level 1
176 Fullarton Road
Dulwich SA 5065
PO Box 754
Kent Town SA 5071
Telephone
(08) 8331 3211
Facsimile
(08) 8331 3749

HEAD OFFICE
Level 1
176 Fullarton Road
Dulwich SA 5065
PO Box 754
Kent Town SA 5071
Telephone
(08) 8331 3211
Facsimile
(08) 8331 3749

Lynda Schenk
Sales Planning Manager
HEAD OFFICE
Level 1, 176 Fullarton Road
Dulwich SA 5065
Telephone (08) 8331 3211
Direct (08) 8422 5702
Facsimile (08) 8331 3749
Website www.normans-wines.com.au
email lynda@normans-wines.com.au

Normans Wines Limited
ACN 007 206 484
Website
www.normans-wines.com.au

CLARENDON WINERY
Grants Gully Road
Clarendon SA 5157
PO Box 695
Clarendon SA 5157
Telephone
(08) 8383 6138
Facsimile
(08) 8383 6089

MONASH WINERY
Nixon Road
Monash SA 5342
PO Box 454
Berri SA 5343
Telephone
(08) 8583 5255
Facsimile
(08) 8583 5444

Tradition can be an enormous advantage and provide impetus to the rejuvenation of a company and its brands. Since its inception, Normans Wines of South Australia had used its family crest as the product's main brand. The new identity incorporated recognisable elements from the crest, while the leaf was used in a more contemporary manner on the Peacock label where it incorporates an image of the founder's wife

Swinburne University of Technology, established in 1909, is an educational institution that delivers vocational, undergraduate and postgraduate programmes with an industry focus. The idea for the identity grew out of the University's solid historical footing, using Swinburne's traditional red, black and white colour scheme with a concept based on the foundation stone which allowed the University's name to be condensed and create a stronger brand identity

We redrew the Arnott's wordmark and combined this with an illustration of the traditional parrot and cracker. The deep red colour that had been consistently used over the years remained the basis of colour identification

Founded in 1865, Arnott's is Australia's best-known and respected biscuit brand. It has an established reputation for quality products and has always maintained a strong visual presence through a number of characteristics that have been consistently used since the brand's inception. When asked to review the brand identity, we were surprised that Arnott's was simultaneously using three conflicting logotypes in the marketplace (above, right and below). In order to develop the new expression of the brand, we first identified the strongest and most consistent characteristics of each logotype. It was fortunate that the company had archived the historical development of its brand and had on hand a wealth of valuable resource material

The revised brand identity (below) was applied to numerous corporate documents, the easily recognised Arnott's trucks, and over two hundred and thirty packs across the company's plain, savoury, cream and chocolate-coated biscuit ranges

MACQUARIE
BANK

Going forward by looking back

Never ignore history. I often remind myself that the business executives we work for are smart. They have not travelled the existing roads without good reason. If the foundations of a company's design solutions are strategically sound, there is often a strong platform for the designers to construct inventive communications. The key elements may sometimes seem outmoded, but it is usually the way in which they are being interpreted or the context in which they are used in the current business environment. I'm yet to meet a designer who hasn't been smart enough to learn from those who preceded them. I'm not referring to those who plagiarise other designers' work; rather, to those who have learnt more from history, from how design has affected business, and to those who recognise that not all knowledge comes from other designers but instead from all areas of life, including business and business executives ■ It's an intriguing concept, 'the client as a designer'. If we refer to the Oxford Dictionary we'll find interesting definitions of the word 'design': mental plan, scheme of attack; contrive; draw plan of. I believe

that by using these definitions, it's possible to conceive of the client as a designer, at least in terms of strategy as well as intent. Given that our predecessors practised similar methods, history can provide us with shortcuts to more highly successful and inventive design solutions. It is for the designer to realise that history is not a barrier to creativity but rather a chronicle of useful information that can be built upon. We have often heard the phrase 'Don't throw the baby out with the bath water'. Just because things aren't right at the time doesn't mean we have to start from square one ■ The genesis of this section is in ideas derived from days gone by. Information relevant to the designer comes from others' triumphs or others' failures, or just simply from others putting their thoughts into action at a previous time

Secretaría de Deportes de la Nación is the National Sports Secretariat of Argentina. The organisation wanted to identify itself with many different sporting disciplines and at the same time retain a very strong institutional character. Its relationship to athletics and the Olympic movement was also an important consideration

Above and opposite: History played a major role in developing the corporate identity programme for a new bank named after Governor Macquarie, a man considered to be the founder of Australian banking. The symbol had its origins in the innovative idea of producing two denominations of currency by stamping out the centre of an existing Spanish coin, the larger section of which became known as the holey dollar. This gave Macquarie Bank a sense of history while providing the organisation with a contemporary trademark that has since gained strong brand presence in the Australian and international marketplaces

The Federal Group developed a number of gaming venues across Tasmania known as The Oasis. Traditional neon lights and casino imagery were the inspirations for the symbol, and the vibrant colours are now highly identifiable and synonymous with these gaming and entertainment venues

giroPost is a banking and payment facility accessed through Australia Post offices. The notion of a continuous circuit of communication and transfer of funds led us to create an identity that conveys movement and security in a form that is easily identified across Australia

MANAGEMENT

STREET ACTIVITY

GROUP

STUDIO